Bruegel

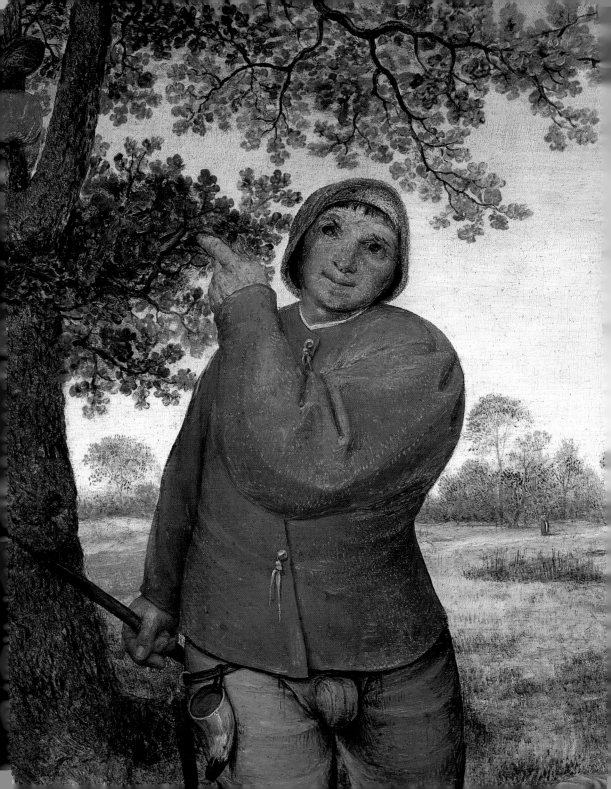

Masters of Art

Bruegel

William Dello Russo

PRESTEL

Munich · London · New York

Front cover: *The Tower of Babel*, 1563, Kunsthistorisches, Vienna Museum (detail); see page 67
Frontispiece: *The Peasant and the Nest Robber*, 1568, Kunsthistorisches Museum, Vienna (detail), see page 123
Back cover: *The Harvesters (Summer)*, 1565, The Metropolitan Museum of Art, New York (detail), see page 91

© Prestel Verlag, Munich · London · New York, 2012
© Mondadori Electa SpA, 2007 (Italian edition)

British Library Cataloguing-in Publication Data: a catalogue record for this book is available from the British Library; Deutsche Nationalbibliothek holds a record of this publication in the Deutsche Nationalbibliografie; detailed bibliographical data can be found under: http://dnb.d-nb.de
The Library of Congress Number: 2012939404

Prestel Verlag, Munich
A member of Verlagsgruppe Random House GmbH

Prestel Verlag
Neumarkter Strasse 28
81673 Munich
Tel. +49(0)89 4136 0
Fax +49(0)89 4136 2335

www.prestel.de

Prestel Publishing Ltd.
4 Bloomsbury Place
London WC1A 2QA
Tel. +44 (0)20 7323-5004
Fax +44 (0)20 7636-8004

Prestel Publishing
900 Broadway, Suite 603
New York, NY 10003
Tel. +1 (212) 995-2720
Fax +1 (212) 995-2733

www.prestel.com

Prestel books are available worldwide. Please contact your nearest bookseller or one of the above addresses for information concerning your local distributor.

Editorial direction: Claudia Stäuble, assisted by Franziska Stegmann
Translation: Jane Michael
Copyediting: Chris Murray
Cover: Sofarobotnik, Augsburg & Munich
Typesetting: Andrea Mogwitz, Munich
Production: Nele Krüger

Printing and binding: Mondadori Printing, Verona, Italy

Verlagsgruppe Random House FSC-DEU-0100
The FSC-certified paper Respecta Satin is produced by Burgo Group Spa., Italy.

ISBN 978-3-7913-4740-0

Contents

Introduction

Many of those who visit the magnificent Bruegel room in the Kunsthistorisches Museum in Vienna, or even the "holy of holies," the rooms dedicated to Bruegel in the Brussels Museum, may say: "I love Bruegel; he's so wonderfully naive!" The Flemish painter, who knew the nature of humanity so well, with all its weaknesses, would probably not have been offended—a shrug of the shoulders, a gentle, ironic smile, and the world continues to turn. His hunters in the snow, trudging home with their dogs, his Tower of Babel reaching up to the clouds, and his peasant wedding, at which all the guests gorge themselves while the bride smiles contentedly, are images that everyone knows, permanently reproduced, even in merchandizing and advertisements.

And yet it would be wrong to see in Bruegel a naive and primitive painter, merely a folk artist. Bruegel was in fact a highly sensitive interpreter of the era in which he lived; an innovator who introduced completely new ideas to art (we need only think of his revolutionary landscapes), and an attentive interpreter of the human psyche, which he observed soberly and largely free of moralistic prejudices.

He spent his short life around the middle of the sixteenth century mostly in Antwerp and Brussels, interrupted by the important, almost paradoxical, experience of his journey to Italy, at the end of which he reached a radical decision: while throughout Europe at that time artists were focusing on a refined Mannerism based on Italian models, he would head in the opposite direction. What he saw in Italy failed completely to provide him with artistic inspiration; apparently he was little moved by his encounter with the works of Raphael and Michelangelo, and classical antiquity, a touchstone for many Italian artists, was of no interest. He was inspired instead by nature and everyday life. He came from the flat and misty landscapes of Flanders, with their subtle color effects. He was also enthusiastic about the snow-covered peaks and rocky landscapes of the Alps, which he had to pass through on his way to and from Italy; and on the Gulf of Naples he seems to have been spellbound by the radiant light of southern climes. In his own landscapes, Bruegel depicted simple people, peasants and fishermen, who toiled all day to earn their daily bread while dreaming of a land of plenty, a world of endless cakes and ale; men and women who live according to the rhythm of the seasons, tilling the fields and herding cattle, their worldview deeply rooted in proverbial wisdom. Bruegel's art paved the way for a secular realism that participates in reality, that consciously seeks to experi-

ence reality instead of merely observing it from a distance. It is here that Bruegel continued the Netherlandish tradition exemplified by artists such as Joachim Patinir, and also Hieronymus Bosch, because he too had no great illusions about the fate that awaited humankind. But in contrast to his predecessors, Bruegel preferred to remain firmly anchored in the here and now, to stand with both feet firmly planted on the Flemish earth, refusing to dream up the fires of Hell or insatiable monsters. Even when he painted religious or mythological scenes, he did not make use of conventional iconographical forms but searched for the human side of the subject, the deeper message. Thus his *Landscape with the Fall of Icarus* is not an exercise in classical rhetoric. He was more concerned to allow the world and nature to follow their own rhythm, unaffected by the great and small stories of man. The small figure of Christ in *The Procession to Calvary* has collapsed under the Cross and can hardly be made out in the vast crowd that has rushed together, surging forward towards Golgotha in order to witness the macabre spectacle of an execution. In *The Conversion of Paul* the real event is observed from the end of a long procession of men on horseback on a steep path in the mountains, as if it were an incidental mishap.

It is because Bruegel tackled his subjects with the utmost freedom and truth that his paintings are still able to communicate impressions, moods, and situations with extraordinary directness and veracity. We must, of course, be capable of distinguishing his hand from the unskilled or cliché-ridden style of his countless imitators. In genuine works by him, the quality of his painting, the sureness of his brushwork, and his love of nature allow us to recognize beneath the surface of his appealing, apparently "simple" scenes the style of a bold, intelligent, and highly innovative artist.

Stefano Zuffi

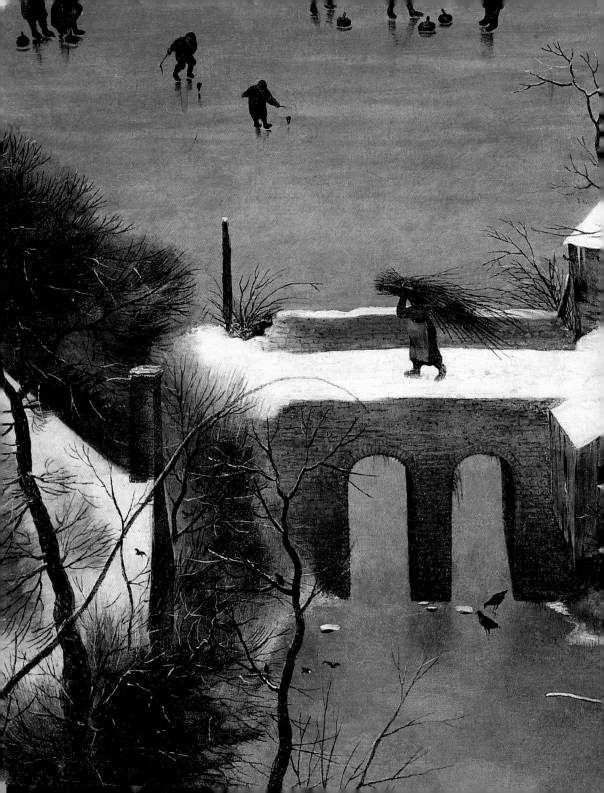

LIFE

Pieter Bruegel – Peasant and Poet

Today the work of Pieter Bruegel the Elder is regarded as one of the highpoints of Flemish, and indeed European, art. His pictures are among the icons of art history and several are internationally famous; his *Hunters in the Snow*, for example, graces countless homes, waiting rooms, and book covers. And yet only around forty of his paintings have survived, executed in a relatively short career, and his status as a well-loved and well-respected master was only recently acquired.

From the comic to the epic

Though he was held in high regard during his own life (a fact confirmed by the many copies made of his works at the time), and though he was long recognized as the "father of secular Flemish art," Pieter Bruegel the Elder was largely neglected until the twentieth century. In part this was because of the vivid but often misleading account of his life provided by Dutch poet and artist Karel van Mander (1548–1606), the most famous of the biographers of the artists north of the Alp), according to whom Bruegel was above all a "humorous" painter. This idea is reflected in his nickname in various languages: Pier den Drol, Brueghel le Drôle, Pietro il Buffo— Bruegel the Droll. Seen as predominantly a painter of burlesque scenes of rustic life, he was also widely known as Bruegel the Peasant.

During the following centuries, when classical subjects and the classical style of painting were widely seen as embodying the highest values in art, and when the "hierarchy of genres" placed scenes of rural life low on the scale of artistic worth, Bruegel was largely underrated. There were just a few exceptions to this tendency, however. One of the most unlikely admirers was Sir Joshua Reynolds, a key advocate and practitioner of the "High Style" of classicism; in his *Journey to Flanders and Holland* (1797) he praised Bruegel's *Massacre of the Innocents* for its "great quantity of thinking." But on the whole it was not until the second half of the nineteenth century that a reassessment began. In two essays published in the 1850s, the French poet Charles Baudelaire rejected the common view that the artist's works were mere "fantasies," finding in them rather "a special kind of Satanic grace," and thereby giving Bruegel a Romantic inflection (the focus here was clearly on Bruegel's designs and paintings influenced by Bosch). Over time advances in historical research helped to establish an authentic body of works (the many misattributions and poor quality copies and fakes had done nothing to enhance his standing) and the close study of the political, religious, and intellectual developments of his day has helped to deepen our understanding of his art (some, for example, claimed to find alchemical symbolism in his works, others related them to the moral and spiritual literature of the time). Changes in art-historical analysis and critical theory likewise opened up new perspectives. From being regarded as a "simple," rather naïve painter of low subjects, Bruegel was increasingly seen as a subtle and intellectually refined artist fully aware of the major religious, intellectual, and artistic trends of his day. Some now see his "realism" as "post-medieval," in other words secular and therefore "modern," while others

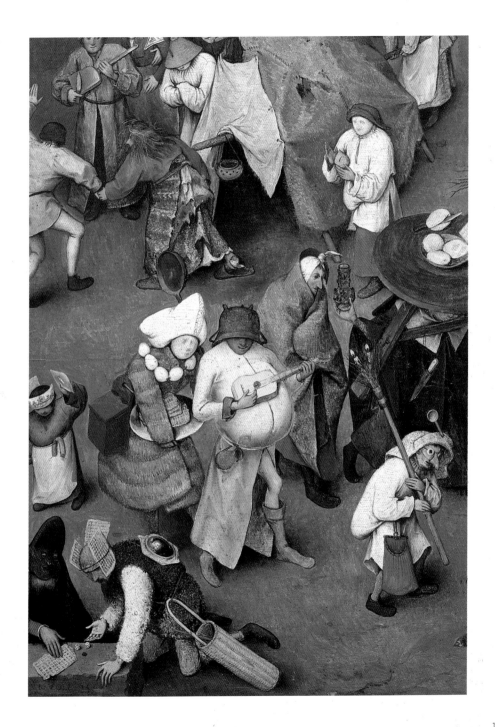

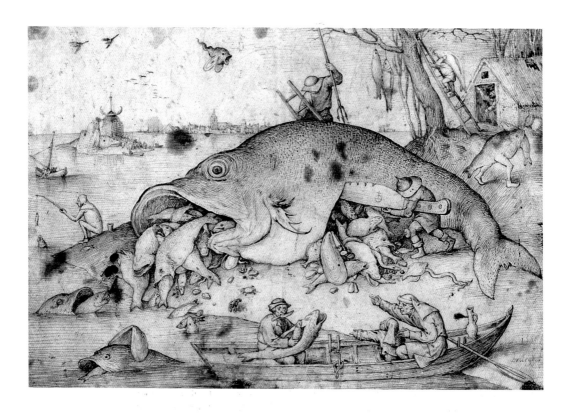

*Big Fish Eat Little Fish,
1556, Kupferstichkabi-
nett, Berlin*

have shifted attention from the content and the intellectual background of his works to the artistry with which they were created—to his highly original approach to composition, perspective, form, and color.

A meager biography

Yet despite the many advances in Bruegel studies, his life, career, and beliefs remain almost entirely unknown. Alluding to one of his most famous works, *The Tower of Babel*, one critic has asserted that those who claim to have found the "real" Bruegel are guilty of "Babylonian arrogance." So there is a need for caution when examining the life and works of Bruegel.

Despite the fame Bruegel enjoyed during his lifetime, the biographical details that

have survived are few and often based on doubtful anecdotes. The only historical biography is to be found in the writings of Karel van Mander, the "Vasari of the North." However, his *Schilder-boeck* (Book of Painters) was not published until 1604, in other words thirty-five years after the artist's death. Even the place and date of Bruegel's birth are not certain. It is generally assumed that he was born in Breda, in northern Brabant (now in the Netherlands). This assumption is supported by the fact that in 1567 the Italian merchant and writer Ludovico Guicciardini (1521–1589), nephew of the celebrated historian Francesco Guicciardini, described him in his *Descrittione ... di tutti i Paesi Bassi* (Description of the Low Countries) as "Pietro Brueghel da Breda," and in the process un-

derlined his links with his predecessor Hieronymus Bosch ("a great imitator of the knowledge and fantasy of the younger Hieronymus Bosch"). For a long time scholars accepted Karel van Mander's claim that Bruegel's family could be traced back to a village in the vicinity of Breda (in fact there are two places with this name), but it must be remembered that "Brueghel" (or "Bruegel," as he signed himself from 1559) was a name that occurred quite frequently in Flanders at the time. There are similar uncertainties regarding his date of birth, for only a few firm points of reference have been established: according to his friend Abraham Ortelius, Bruegel died in Brussels in 1569 "in the prime of life," in other words presumably in his forties; he was accepted into the Guild of St. Luke—the painters' association—in 1551, which could not have happened before the age of twenty-one or even, according to some sources, twenty-five. This suggests that he was born around 1526, in any case between 1525 and 1530. There are no clear indications of his social background or the family from which he came (though it was long assumed he was from peasant stock), and very little is known about his life before 1551.

Van Mander also claims that Bruegel was apprenticed to Pieter Coecke van Aelst (1502–1550), a well-known artist who was strongly influenced by the examples of Renaissance art he had seen during a long stay in Italy. This Flemish eclectic was court painter to Emperor Charles V, had visited the Orient, and had translated the architectural writings of Vitruvius and Sebastiano Serlio. Dean of the Guild of St. Luke, he was the head of a flourishing workshop that produced stained-glass windows, miniatures, and watercolors as well as oil paintings. Coecke van Aelst's wife, Mayken Verhulst Bessemers, Bruegel's future mother-in-law, also helped to produce the miniatures and watercolors, and we also know that she taught Pieter's second son, Jan, later known as Jan Brueghel the Elder, to paint in tempera. It was probably due to her influence that some of Bruegel's works are painted on canvas, at a time when wood panels were still the predominant support.

However, it is also possible that Bruegel's apprenticeship under Coecke van Aelst was later assumed by van Mander because of the family relationship established at a later date. It has been pointed out, for example, that his art is almost entirely free of the influence of Italian art, while Coecke van Aelst was one of its principal exponents north of the Alps. Whether or not Bruegel really did learn his trade from Coecke van Aelst, it is significant that also working in his workshop was an important artist who is known to have played an important role in Bruegel's artistic training, not only as regards basic technique but also with respect to figurative composition: Jan van Amstel (1500–c. 1540, formerly known as the "Brunswick Monogrammist"), the elder brother of the better-known Pieter Aertsen (1508–1575) and brother-in-law of Coecke van Aelst. In 1980, Matthijs Coeck (c. 509–1548), the brother of Hieronymus Coeck (or Cock), was also identified as an artist who may have had an influence on Bruegel, in particular on his approach to landscape painting.

Key dates in Bruegel's career are the years 1550, when Coecke van Aelst died and Bruegel probably moved to Antwerp, and 1551, when Bruegel became an independent artist. It was at this time that Bruegel's artistic personality began to form, and his move to Antwerp allows us to recreate the economic and social context in which he now lived and worked. At that time, Antwerp was flourishing economically and gaining in importance nationally and internationally. If we accept Guicciardini's assessment, the only city that rivaled it as a center of European finance was Venice. He claims that over 360 artists were working in Antwerp, a truly extraordinary number that (even if it is an exaggeration) clearly indicates the presence in the city of an important class of clients and patrons who fueled an increasing demand for artworks and luxury goods. Nonetheless, the city was already characterized by profound social contrasts resulting not least from the fact that various religious confessions—Catholics, Lutherans, Calvinists, and Baptists—lived there side by side. The strongest cause of instability, however, was Spanish rule, which eventually led to open rebellion.

The first record of Bruegel's activity as an artist is documented in 1550. In the workshop of a certain Claude Dorizi, and together with the painter Pieter Balten (or Baltens) (c. 1527–1584), he assisted in the painting of a triptych for the Guild of Glovemakers in St. Rumold's Church in Mechelen (halfway between Antwerp and Brussels), an altar that unfortunately has not survived. Bruegel's task was to paint two *grisaille* figures of saints on the wings.

Contact with Italy

In 1553 Bruegel left Antwerp in order to spend several years in Italy—a journey to Italy had become essential for any artist who wanted to rise above the status of a mere craftsman. It is possible that Coeck van Aelst encouraged him to make the trip, though it is also possible that Bruegel simply wanted to enlarge his circle of clients and patrons. Curiously, there is no evidence of the influence in his art of the Italian models that Bruegel was now able to study at first hand; at least none that is immediately apparent (the few signs there are may have been derived from Italian works in the Netherlands, such as Raphael's tapestry cartoons). Though we cannot discern any clear artistic influences, there were certainly landscapes that left a deep impression. The precise itinerary of his journey is still the subject of debate, however, for there are no written records to show which places he visited. So we have to deduce the stages of his journey from certain paintings and drawings, which he produced either in situ, or after his return to the Netherlands. He probably stopped over in Lyon first of all, and crossed the Alps via the Mont Cenis Pass. We can assume he then traveled to Bologna and later visited Naples, after making a detour to Rome. He next traveled through southern Italy, visiting Reggio di Calabria and other locations. We can find reminiscences of Naples some years later in a painting he executed at a later date (c. 1556), his *Naval Battle in the Gulf of Naples*, today in the Galleria Doria Pamphilj in Rome.

Bruegel's visit to Calabria is documented by a famous drawing in the collection in the

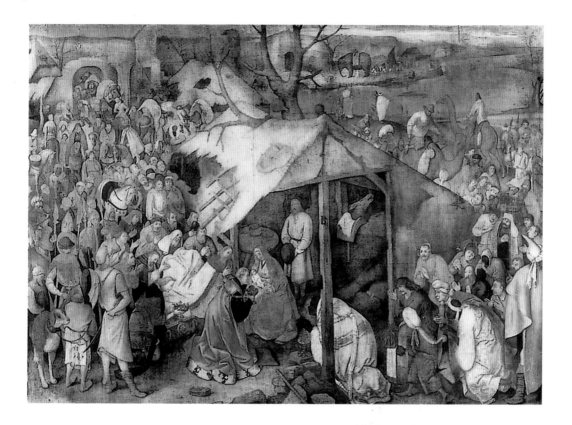

Museum Boijmans van Beuningen in Rotterdam. It shows a stretch of coastline on the Strait of Messina together with the naval battle against the Ottoman Turks that took place there in 1552, pictorial elements that recur in a painting entitled *Naval Battle in the Strait of Messina* (c. 1552/53, private collection, New York), though the attribution of this work is still open to debate. It also seems very likely that he made a detour to Palermo, where the fresco *The Triumph of Death* (1446, artist unknown, today in the Palazzo Sclafani), may have inspired some of the landscape elements in his painting of the same name (c. 1562) in the Museo Nacional del Prado in Madrid.

There is also a great deal of uncertainty about his return journey. What is definitely known, however, is that he spent some time in Rome and its environs; though documentary sources make no mention of it, a number of relevant drawings have survived; especially a view of a port of the Tiber River in Rome, the Ripa Grande, a work now in Chatsworth House (Derbyshire); and an engraving of Tivoli. There is also evidence of his Alpine crossings (Alpine gorges and snowy peaks are elements that recur throughout Bruegel's oeuvre, in both paintings and graphic works); of his traveling through Ticino to the Great St. Bernhard Pass and the Swiss village of Waltensburg; and, according

The Adoration of the Kings, c. 1556, Musées Royaux des Beaux-Arts, Brussels

to some authors, of a visit to Innsbruck and the surrounding area. In this context it is helpful to remember van Mander's assessment that the Alps made such an impression on Bruegel that he "swallowed all the mountains and rocks and spat them out again as panels on which to paint, so close did he attempt to approach nature in this and other respects." It is not very likely that Bruegel depicted specific landscapes; we must assume instead that his landscapes are composite scenes, often with both Flemish and Italian components.

It is also interesting to consider the people Bruegel may have met during this journey. Who were his companions and patrons? We can be sure that the Flemish artist Marten de Vos (c. 1532–1603), who was in Italy from 1552 to 1558 to complete his training, accompanied him at least part of the time. Some have speculated that de Vos contributed the figures to Bruegel's first major landscape painting, *Landscape with Christ and the Apostles at the Sea of Tiberias* (1553, private collection), a work that contains the germ of Bruegel's basic conception of landscape painting—a conception that has its Flemish roots in the art of Joachim Patinir (c. 1480–1524), who can certainly be regarded as one of Bruegel's most important predecessors as a landscapist. It is also known that while in Italy Bruegel collaborated with the Italian artist Giulio Clovio (1498–1578), perhaps the most important miniaturist of his age (Giorgio Vasari considered him to be unsurpassed in this art); in the inventory of Clovio's estate were listed two views of Lyon in gouache attributed to "Pietro Brugole." In

Clovio's workshop Bruegel almost certainly saw a copy of the illuminated book the *Breviarium Grimani*, which may well have supplied him with motif for one of his greatest works, *The Tower of Babel* (two versions, Vienna and Rotterdam); the Clovio inventory also lists a painting on ivory of the same subject. Significantly, Bruegel's hand has been discerned in several miniatures in the *Ore Farnese*, a Book of Hours that Clovio created for Alessandro Farnese (today in Pierpont Morgan Library, New York).

Antwerp: patrons, merchants, and first masterpieces

After his return to Antwerp—the date is uncertain, but is generally assumed to have been 1555—Bruegel established contact with a number of people who would play a decisive role in his career, even after he moved to the capital, Brussels. They included art collectors, Church dignitaries, merchants, and figures prominent in the intellectual and cultural life of the Netherlands. Together with Giorgio Ghisi (1520—1582), an engraver from Mantua who specialized in the reproduction of famous works of art, Bruegel began working for Hieronymus Cock (c. 1510–1570), one of the best-known copperplate engravers and printers of his time. He directed the highly successful studio "In de Vier Winden" (To the Four Winds), which specialized in reproducing the most celebrated works of Flemish and Italian art as engravings. As Hieronymus Bosch was particularly popular, Bruegel's early graphic works were stylistically very close to the works of the older master; in some cases

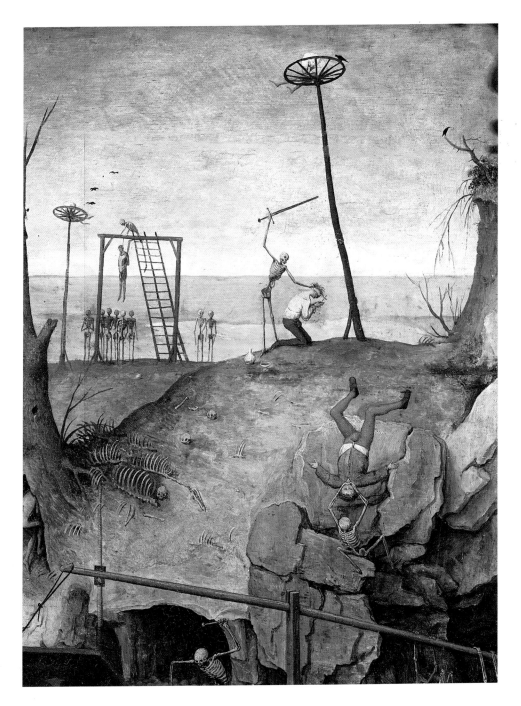

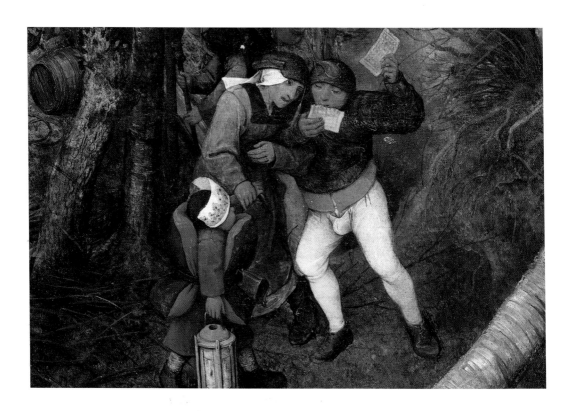

The Gloomy Day (February–March / Early Spring), 1565, Kunsthistorisches Museum, Vienna (detail)

Bruegel took motifs directly from Bosch, thus causing some confusion as to which of them created certain works. "He had worked a great deal after the pictures of Hieronymus Bosch and also painted many spectral pictures and humorous scenes, which is why many people also called him 'Pieter the Droll'." This trenchant characterization by Karel van Mander, which was to have far-reaching consequences for the history of Bruegel's reception, refers above all to works that are entirely focused on the portrayal of grotesque and fantastic figures. When Bruegel was described as a "second Bosch" or the "new Bosch" (as Vasari, for example, called him), the reference is primarily to the years in which Bruegel drew

countless designs for engravings, exclusively on the instructions of Cock. Among the major series from this period is *Great Landscapes* (1555), in which the basic elements of his approach to landscape are already firmly established. Among the single sheets produced the following year, *Ass at School* and *Big Fish Eat Little Fish* (both Kupferstichkabinett, Berlin) show the unmistakable influence of Bosch. Further outstanding works from this very productive period are the designs for the series *The Seven Deadly Sins* (1556/57) and *The Seven Virtues* (1559/60).

It is clear that at this time Bruegel concentrated on graphic work; the first surviving signed and dated painting was not produced

until 1557: the landscape *The Parable of the Sower*, now in San Diego.

It was during this period, before his move to Brussels around 1563, that Bruegel became one of the most sought-after artists in the region. His clients were predominantly wealthy secular patrons, who commissioned paintings to furnish their residences, but he also received a number of commissions from those close to the Catholic Church. Indeed, one of the first known collectors of Bruegel's works was a man of the Church: Cardinal Antoine Perrenot de Granvelle, an adviser of Philip II of Spain and until 1564 President of the Council of State of the Netherlands and Archbishop of Mechelen. We know that he owned *The Flight into Egypt* (1563) as well as three further (as yet unidentified) paintings by Bruegel. The banker Niclaes Jonghelinck assembled a collection of no fewer than sixteen paintings by Bruegel, which he hung in his fine Antwerp residence. Documentary sources also establish a close connection to the geographer and scholar Abraham Ortelius (1527–1598), who is regarded as the creator of modern cartography. However, there is no certain proof as to which works were in Ortelius's possession apart from the *grisaille* painting *The Death of the Virgin* (c. 1564). Ortelius's scientific knowledge and his sound education can hardly fail to have had an effect on the general conception of Bruegel's art. This can be deduced, for example, from the construction of the pictorial space in his paintings, which is in marked contrast to the generic character of the representation of landscape and architecture

seen in the final phase of Late Gothic panel painting and book illustration.

The cultural circles in which Bruegel moved also included personalities of the standing of the writer and philosopher Dirck Volkertszoon Coornhert (1522–1590), who worked as a copperplate engraver, and the important printer and publisher Christophe Plantin (Christoffel Plantijn, c. 1520–1589).

The fact that Bruegel painted for specific clients helps to explain why his works are largely dedicated to secular themes. Even works with religious subjects generally go beyond the simple depiction of a biblical event, which is typically reduced to a seemingly insignificant incident embedded in a broad landscape. The only example of a work from these years with a mythological subject is his *Landscape with the Fall of Icarus* (c. 1558). But here again, while this wonderful painting can be seen as a homage to the classical myths narrated by the Roman poet Ovid, it is above all a depiction of the vastness—and seeming indifference—of nature, the landscape being seen, as so often, from above. All that we see of Icarus are his legs as he plunges into the sea!

The year 1559 marks the beginning of a decisive phase in Bruegel's artistic development. It was in this and the following year that he produced three of his most important—and most famous—paintings. Their remarkable originality derives from the fact that they do not refer directly to literary sources, though Sebastian Brant (1494), Erasmus of Rotterdam (1524), and François Rabelais (1532) created comparable works in literature. They are *The Netherlandish*

Proverbs, *The Fight Between Carnival and Lent,* and *Children's Games.* The teeming mass of figures in these paintings—each is populated with dozens of precisely rendered characters—by no means impairs the overall coherence or even plausibility of the representation. By this stage—after so much work as a graphic artist—Bruegel was already able to arrange large numbers of people in his pictures according to an overall geometrical structure. Within this structure, the figures individually are both vivid and convincing depictions of various types, and also effective illustrations of a wide range of activities, games, and proverbs. Karel van Mander was referring to these multi-figured representation when he wrote: "He produced few pictures which the viewer can regard seriously, without laughing; indeed, no matter how withdrawn and morose he is, he will at least have to smile"—thereby fatefully characterizing Pieter Bruegel as (merely) a humorist.

We can assume that the interpretation of the many activities depicted in these paintings has become more difficult over the course of time, and that Bruegel's contemporaries could decipher the scenes much more easily that we can. What is clear, at least, is that Bruegel's visual art is closely linked to the vitality and wit of the Dutch language, especially as regards proverbs, puns, and jokes. How exactly these works should be interpreted is still widely debated. Were they principally instructive moral tales, or—albeit on the highest artistic level—encyclopedic illustrations of the traditional folk life, the proverbs, customs, and games, of that

age? Was the intention to reform or to educate? In recent literature there has been a clear desire to downplay their moral and educational intent. The emphasis now is not on systematically identifying and decoding the various components, but rather on showing how skillfully Bruegel used such familiar material in his art (his graphic and painterly means), and on exploring how his treatment reflects his deeper understanding of the world and of man.

A further key date for an understanding of Bruegel's development is 1562, the year in which he painted *The Fall of the Rebel Angels*, *"Dulle Griet"* (*Mad Meg*), and very probably also *The Triumph of Death*. They are all apocalyptic pictures in which Hieronymus Bosch is once again the direct inspiration, though Bruegel interprets the Boschian motifs in a highly original way. It may well be that they were painted to order for clients who wanted works "in the style of Bosch," and not out of personal inclination. For during this same year Bruegel painted *Two Monkeys*, a work that is stamped with a very personal awareness, a poetic intimacy, that leaves the terrors of the visions of Hell far behind. Within the small format of *Two Monkeys* (it measures just 20 x 23 cm), Bruegel seems to have affirmed his links with the city that he was just about to leave: the view in the background is of Antwerp. At this time Bruegel also painted *The Suicide of Saul*, his first (surviving) painting of a subject taken from the Old Testament. And here again the stated subject is subordinate to a vast landscape that is presented with such care and in such detail that it may well have been based on

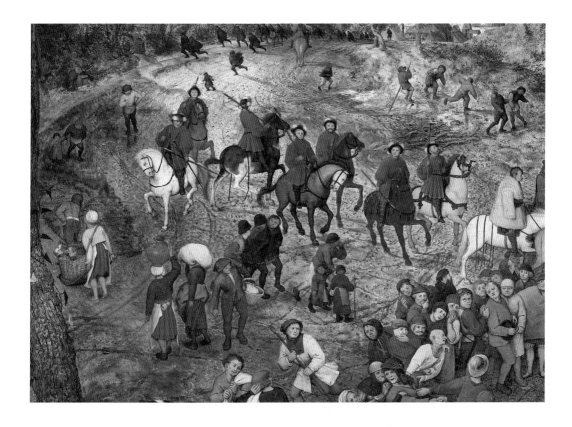

cartographic models of the kind that fascinated his friend Ortelius. The religious subject seems little more than a pretext.

Brussels and success

On Easter Sunday 1563 Bruegel married Mayken Coecke, the daughter of his former teacher, in the Church of Notre-Dame-de-la-Chapelle in Brussels. She was just eighteen years old and, as Karel van Mander reports, Bruegel (who must have been in his thirties when they married) had carried her around in her father's workshop when she was a child. Was the reason for Bruegel's move from Antwerp to Brussels his alleged relationship with his maid and the resultant

insistence of his mother-in-law that he move to the capital? Or did he have to leave because, as some sources claim, he feared being accused of heresy, in an age when every deviation from the "true path" in religion was punished severely? His circle of friends included several controversial figures.

In Brussels he continued to work for his previous clients, especially Niclaes Jonghelinck. He produced two versions of *The Tower of Babel*, incomparable allegories of a sin to which all men fall prey—pride. Various interpretations have suggested linking this work to contemporary social and religious forces. Did Bruegel see Antwerp (the city usually associated with the image) as the

The Procession to Calvary, 1564, Kunsthistorisches Museum, Vienna (detail)

21

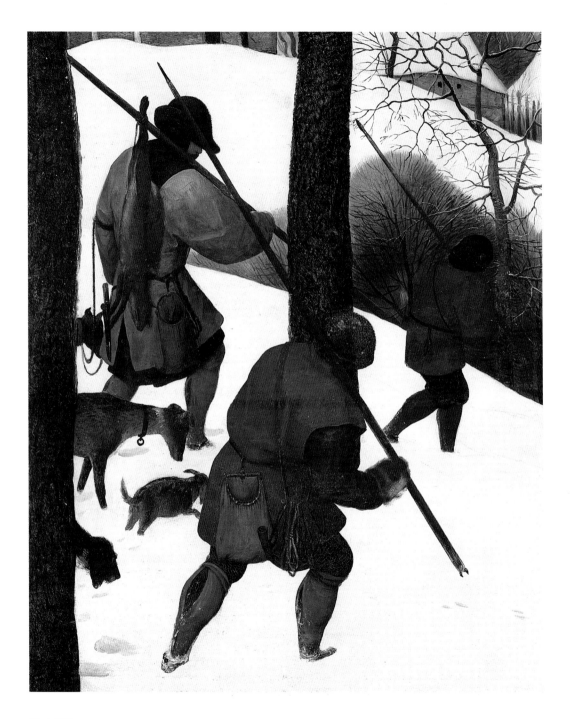

"Babylon" of his age, a bustling trading city in which countless languages were spoken? Or was he intending a scarcely disguised criticism of the Reformation? Perhaps the Tower of Babel might allude to the confused mix of faiths (Catholics, Reformers, Baptists and so on) who, now speaking "different languages," were compelled to live together.

Bruegel painted a number of major religious works around this time, all of them for secular clients, with paintings such as *The Procession to Calvary* (Vienna) and *The Adoration of the Kings* (London) clearly demonstrating very different approaches to sacred subjects. Though both were painted in 1564, the two works are diametrically opposed not only in subject and theme (the death of Christ and birth of Christ respectively) but also in composition. In the first, the people who form the closely packed crowd are indifferent witnesses of a death that will change the course of world history: interested only in a bloody spectacle, they fail to recognize the universal significance of this event; only the figures in the foreground understand this world-changing event (depicted in antique costume, the two main figures represent Mary and St. John).

While *The Procession to Calvary* shows a multitudinous tumult (it is the largest of Bruegel's landscape pictures), *The Adoration of the Kings* focused closely, almost claustrophobically, on the main event, so that there is little sense of depth. Though the kings are finely dressed, the two on the left are old, almost senile, and the people behind them unattractive and some even stupid, as though

unaware of the significance of what is happening. Even the Virgin is not idealized.

The claim that Raphael's famous tapestry cartoons, which had been in Brussels for half a century at this stage, might have provided inspiration for several of the figures in *The Adoration of the Kings* is still open to question. However, it is clear that this is one of the very few compositions by Bruegel in which echoes of the Italian tradition are not merely superficial. In this same group is a picture produced the following year: in the *grisaille* painting *Christ and the Woman Taken in Adultery* (1565) Bruegel created one of his finest female figures, a woman of impressive beauty and gentle humanity. Worlds separate this elegant and ethereal female figure from the earthy, heavy-set rustics who usually inhabit his pictures.

A further purely biographical event also took place in 1564: the birth of his eldest son Pieter, later known as Pieter Brueghel the Younger and also "Hell Brueghel," after his images of Hell. He would later specialize in copying his father's paintings.

The Seasons

It was during the following year, 1565, that Bruegel achieved the status of a universal genius in the field of landscape painting. The five surviving paintings of the Seasons Cycle represent his mastery of technique and composition in a genre (depictions of the seasons) that by that time was already fully developed. They can be seen as the epitome of Netherlandish landscape painting, in which he was preceded by Joachim Patinir and succeeded by Peter Paul Rubens (1577–

Opposite page: The Hunters in the Snow (December–January / Winter), 1565, Kunsthistorisches Museum, Vienna (detail)

1640). The approach to landscape seen in medieval Books of Hours, which typically included depictions of seasonal rural occupations, was now full surpassed. In its place appeared an "affective" attitude to nature. For in Bruegel's cycle, man and nature are closely linked. Time and again nature subjects man to arduous toil, exhausts him, permeates him so that he becomes like a piece of mosaic, an unimportant, replaceable element of the natural world. Nature remains indifferent to man and itself undergoes during the course of the seasons an eternal cycle of change, of death and renewal, that is reflected in form and color. The pictorial strategy Bruegel employed in order to present a picture of the infinity of nature consists above all of depicting a landscape from an elevated, bird's-eye view, an approach that, though used before, had never been systematically adopted of all the pictures in a cycle. They are composed so that we enter the picture at ground level but can look down on a landscape that stretches away into the far distance. This approach was largely new in art north of the Alps, though it had been anticipated by Patinir. Bruegel's landscapes convey the convincing impression that the landscape extends towards an infinitely receding horizon.

But how can we explain the fact that Bruegel planned the series to include six pictures and not four, which would correspond to the number of seasons? For a long time scholars debated the idea that he might have planned to produced a picture of each month, so that the cycle was originally intended to extend to twelve pictures. This view

has largely been superseded today. Current research has come to the conclusion that the pictures were dedicated to pairs of months; only the picture for the months April–May is missing. In northern Europe the calendar was indeed often divided into six seasons. In addition to the familiar four seasons there are also two transitional seasons: early spring and early summer. Until 1575, Easter marked the start of the year, which is why the first picture in the series is regarded as being early spring (February–March), in other words the painting *The Gloomy Day*.

Some scholars argue that the cycle in the residence of Niclaes Jonghelinck was originally mounted as a sort of continuous picture frieze. Jonghelinck's collection of art works was later acquired by the City of Antwerp as security for a bond that was not redeemed. It included other masterpieces by Bruegel, such as *The Tower of Babel* and *The Procession to Calvary*, as well as a painting by Albrecht Dürer (1471–1528) and a number of works by Frans Floris (1517–1570). The paintings were then surrendered in 1594 to Archduke Ernst, the younger brother of Emperor Rudolf II and governor of the Netherlands. They thus became the foundation of the impressive collection of Bruegels in the Kunsthistorisches Museum in Vienna. If we compare the figures and animals of the Seasons Cycle with those in the paintings of his early phase, and in particular with the works based on Hieronymus Bosch, it is striking to see that there are now only a handful of figures, and that they are much larger and more powerful. This is a process typical of Bruegel's overall development: an increasing reduction until, in the

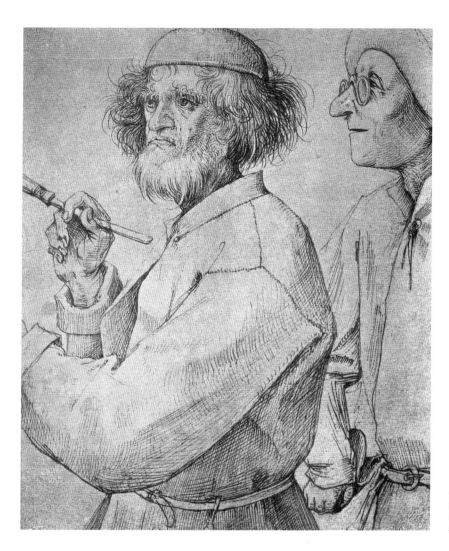

*The Painter and the
Connoisseur, 1565,
Grafische Sammlung
Albertina, Vienna*

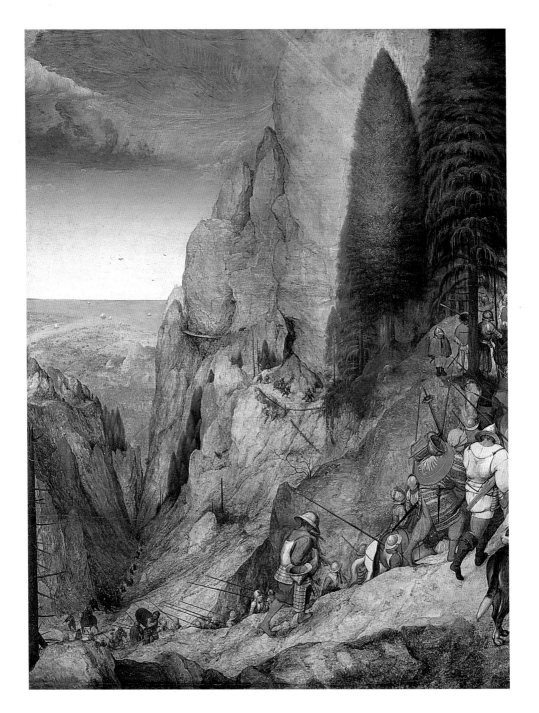

last works, an expressive monumentality is achieved that is far removed from the crowded profusion of the early works.

Bruegel's last years and artistic legacy

From 1565 until he died in 1569, Pieter Bruegel's artistic productivity increased exponentially. With the same authority with which he created universal landscapes such as the Seasons Cycle, he turned to painting peasant motifs such as *The Wedding Dance* (1566), *The Peasant Wedding* (c. 1568), and *The Peasant Dance* (c. 1568). It is these works that contributed in no small measure to the description of the artist as "Peasant Bruegel," in other words a painter whose interest lay primarily in rural subjects. And they do indeed display (as well as a sure sense of composition and color harmony) a very precise knowledge of rural life. The exact purpose of these scenes remains unclear, though after long and animated debates among Bruegel scholars many authors have finally abandoned all forms of moralizing interpretations. They no longer see a deprecatory or satirical intention in the representation of the lower classes of society. Indeed, for some Bruegel's vivid and lusty depictions of rural life can be seen as forming part of a growing sense of national identity. According to van Mander, Bruegel, accompanied by Hans Franckert, a Nuremberg merchant and well-known art-lover, visited rural celebrations in order to "observe the nature of peasants when eating, drinking, dancing, leaping, celebrating, and engaged in other amusing activities, a succession of moments that he was able to reproduce at-tractively and amusingly with his paintbrush, using both watercolors and oil paints, for he was very skilled in the use of both."

Three further pictures painted during these years should also be mentioned here since they demonstrate Bruegel's extraordinary skill in depicting winter landscapes. It seems that in such works as *The Massacre of the Innocents* (c. 1564), *Winter Landscape with a Bird Trap* (1565), and *The Census at Bethlehem* (1566) Bruegel was drawing upon memories of the exceptionally cold winter of 1564/65. This group of winter pictures (which was preceded by the associated Seasons Cycle) culminates in the *Adoration of the Magi in the Snow* (1567) in Winterthur, a small-format masterpiece that is nonetheless important for its reproduction of subtle atmospheric effects—it is indeed the first depiction of *falling* snow in Western art.

Other events at this time, religious and political, may also have had an impact on Bruegel's art. In August 1566, iconoclastic riots erupted, during which numerous paintings and other artworks were destroyed in churches throughout the Netherlands—an open revolt against the supposed veneration of images in Catholic churches. During the following year, the Duke of Alba, the representative of the devout Catholic Philip II, entered Brussels in triumph at the head of an army of 60,000 soldiers. This was followed by a real reign of terror that continued until 1573. It was in the period between these two historical events that Bruegel painted *The Sermon of John the Baptist* (1566) and *The Conversion of Paul* (1567). Both are monumental works whose religious meaning is

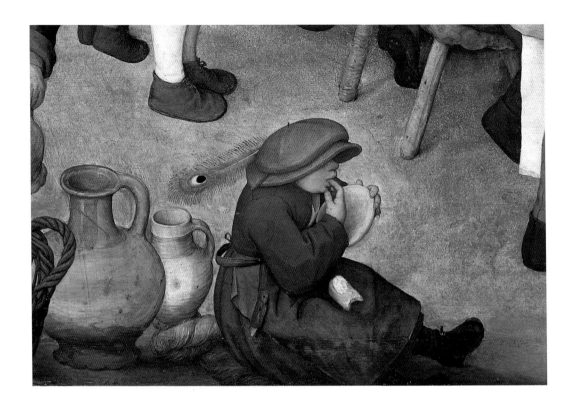

The Peasant Wedding,
c. 1568, Kunsthis-
torisches Museum,
Vienna (detail)

difficult to interpret. What is clear, however, is that here Bruegel reached an artistic peak in his treatment of space.

A similar originality can be seen in the secular paintings he executed at this time, notably *The Land of Cockaigne* (1567), *The Beggars (The Cripples)* (1568), *The Blind Leading the Blind* (1568), and *The Peasant and the Nest Robber* (1668). What they have in common—apart from the fact that their subjects are by no means "noble"—is their highly original treatment of the picture space. Art historian Piero Bianconi has pointed out that the most important characteristic of Bruegel's compositions is "the tendency to concentrate natural forms in simple geometric figures, the cylinder, cone, and sphere," and that it is

this—together with his distinctive "primitivism"—that makes his depiction of everyday objects look so unusual. This process of simplification can be observed in two paintings from much the same period, *The Bad Shepherd* (lost, though a copy by an imitator has survived and is today in the Philadelphia Museum of Art), and *The Good Shepherd* (lost, several copies). In both of these paintings objects are reduced to three-dimensional forms that are clearly delineated and depicted with an extremely bold use of central perspective.

Two further important incidents are recorded relating to the last years of Bruegel, who probably died in his forties. Shortly before his death, the City of Brussels commissioned him to paint the new

canal between Brussels and Antwerp, which was completed in 1565. We can assume that the city officials had been impressed by the remarkable skill with which Bruegel represented the building work in *The Tower of Babel*.

The second incident, an anecdote recorded by Karel van Mander, has given rise to a good deal of speculation as to Bruegel's political and religious beliefs. Van Mander claims that shortly before his death, Bruegel asked his wife to burn certain drawings "from remorse or for fear that she might get into trouble and might have to answer for them." The nature of these drawings, described by van Mander as "biting and sharp," has never been clarified. It may be significant, however, that political and religious tensions were high; it was only a few months before his death that he was released from the obligation of having Spanish soldiers (who occupied Flanders at the time) billeted in his home.

"The most important artist of his time" (as his friend Ortelius called him) died on 5 September 1569 and was buried in the Church of Notre-Dame-de-la-Chapelle in Brussels.

The tomb was decorated by the painting *Christ Giving St. Peter the Keys of Heaven* (Gemäldegalerie, Berlin), executed by perhaps his most important "successor": Peter Paul Rubens, a friend and close associate of Jan Brueghel; Rubens recalled his famous compatriot more than once in his own works.

Formerly, the painting *The Storm at Sea* (Kunsthistorisches Museum, Vienna) was seen as a symbolic conclusion to Bruegel's life and works. Today, however, it has been ascribed to Joos de Momper (1564–1635) and so deleted from the catalogue of Bruegel's works. His last work is now thought to be *The Magpie on the Gallows* (1568), a work that presents a great challenge to scholars, with various conflicting interpretations being provided, notably with regard to the meaning of the two elements referred to in the title, the gallows and the magpie. A definitive account will probably never be provided. We are left with the simple observation that it presents a landscape of overwhelming beauty in which the affairs of men appear so insignificant and irrelevant that the viewer has only one wish: to become one with nature.

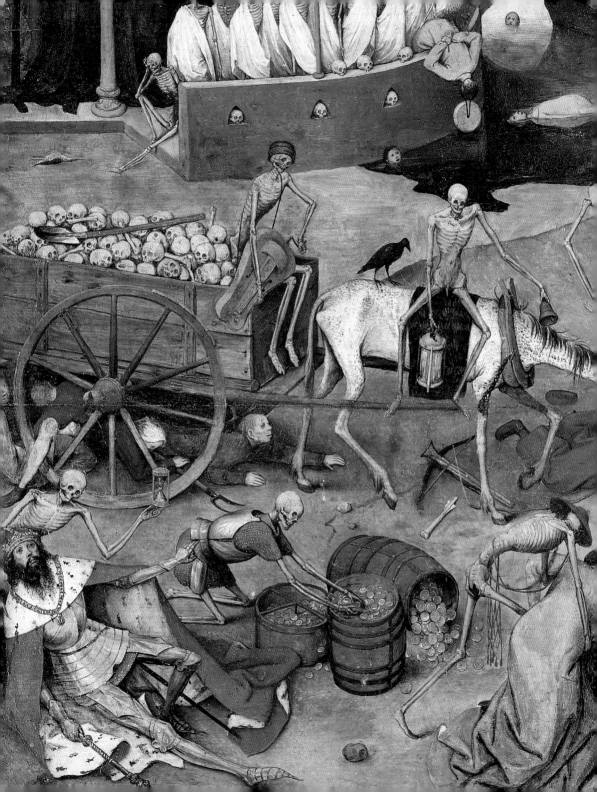

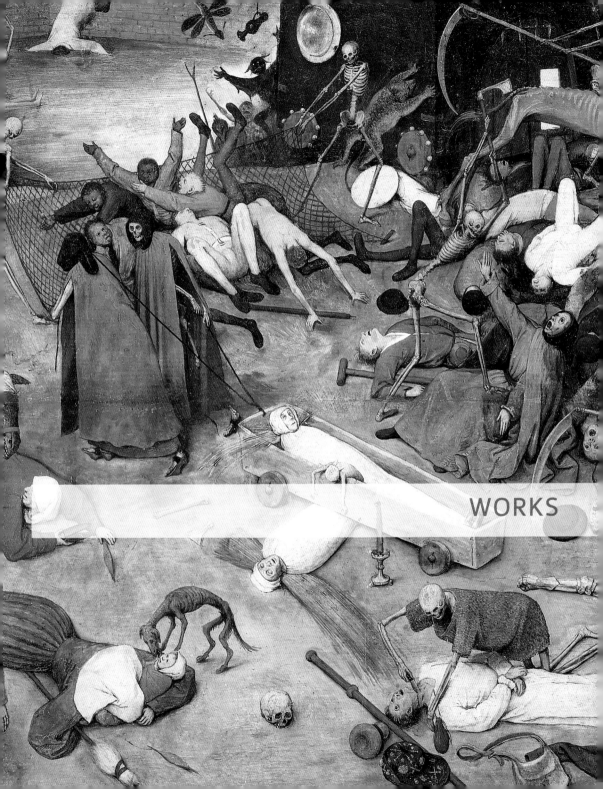

WORKS

Naval Battle in the Gulf of Naples

c. 1556

Oil on wood, 39.8 x 69.5 cm
Galleria Doria Pamphilj, Rome

The attribution of this painting to Bruegel is not entirely convincing, and yet the view is very like that seen in a print of a naval battle in the Strait of Messina that was engraved in 1561 by Frans Huys after a drawing by Bruegel, and distributed by Hieronymus Cock. It is also worth noting that Bruegel had previously created views of the Italian coast, including a drawing now in Rotterdam (Museum Boijmans van Beuningen) and a painting attributed to him, *Naval Battle in the Strait of Messina* (c. 1552/53, private collection), which almost certainly depicts the coast between Messina and Reggio di Calabria. The landscape in the background of *The Triumph of Death* (c. 1562), too, is reminiscent of this coastal area. The inventories of early Bruegel collectors mention two seascapes. The first of these was in the possession of Cardinal Antoine Perrenot de Granvelle, the second in the collection of the painter Peter Paul Rubens. Whether this is "simply" a view of the port of Naples, or whether it is a representation of a particular naval battle (as suggested by the clouds of smoke) is unclear. From left to right, we can see the Castel dell'Ovo, the tower of San Vincenzo, and the castle of Maschio Angioino, with Mount Vesuvius on the far right. In contrast, the representation of the crescent-shaped mole, which did not exist, is romanticized. Bruegel's sojourn in the southern Italian city ended no later than the year before the execution of this painting, so it is likely that he created it after his return to the Netherlands.

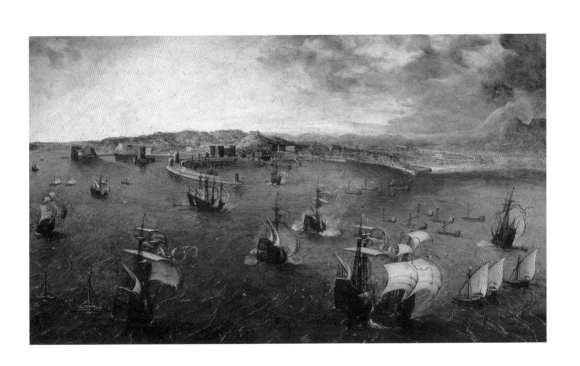

Parable of the Sower

1557

Oil on wood, 74 x 102 cm
Timken Museum of Art, San Diego

This is the earliest surviving painting actually dated and signed by Bruegel. The earliest painting attributed to him, *Landscape with Christ and the Apostles at the Sea of Tiberius* (private collection, New York), is dated to 1553. Some authors believe that *Naval Battle in the Strait of Messina* (c. 1552/53, private collection) also belongs to this first group of works; according to tradition, it is simultaneously a view of the coast between Reggio di Calabria and Messina and an allusion to the biblical story of the destruction of Sodom.

In these early works by Bruegel, the biblical episodes are already isolated; they seem like mere incidents in a virtually cartographical representation of a vast and magnificent natural environment. The elevated point of view allows a much larger expanse of land to be shown than would have been possible from a lower vantage point. The tendency to limit views using natural "pieces of scenery" to create the impression of a foreground can already be observed here, too. In this painting they are particularly high, only to become smaller and smaller as they recede into the background. Here it is the tree in the left foreground that helps to establish a sense of scale and distance in relation to the background. Differentiated according to spatial depth, the coloring, ranging from the bold shades of brown in the foreground via green to light blue, heightens the impression of considerable distance and makes the perspectival representation of the landscape all the more convincing. While people have come together on the beach in the middle ground to listen to the words of Jesus, the farmer in the foreground sows his seeds on a different soil; both "will bear fruit."

Landscape with the Fall of Icarus

c. 1558

Oil on canvas, transferred to panel, 73.5 x 112 cm
Musées Royaux des Beaux-Arts, Brussels

Bruegel painted two versions on this subject. The one not reproduced here, a wood panel, is in Brussels, too, in the collection of David and Alice van Buuren, and depicts Daedalus in flight. The predominant opinion among researchers is that both are copies of a lost original by Bruegel. These two paintings are of special interest in Bruegel's oeuvre as they are the only two known paintings by him on a subject drawn from classical mythology. The story from Ovid's *Metamorphoses* is traditionally interpreted as an allegory of hubris, or human presumption. As Icarus flies too close to the Sun ("flies too high"), his fall is unavoidable: the celestial body's heat melts the wax with which the feathers have been attached to the wings that his father, Daedalus, made for him. In this early work, Bruegel used a compositional technique that would become a constant in his oeuvre: the protagonist is shown in an inconspicuous position; in this instance, only his legs are visible, jutting out of the water. The rest of the painting is dominated by the expansive coastal landscape. A sailing boat plows through the waves in the foreground, but the crew takes no notice of the fatal accident. Three classic figures of the Ovidian story can be seen on the mainland: (from left to right) a farmer, a shepherd, and a fisherman. They, too, appear unmoved by the unfortunate man's fate. The farmer continues carefully to plow his fields, possibly in reference to the Dutch saying "One does not stay the plow for one who is dying." Only the shepherd appears to be aware, for a moment, of the misfortune that has befallen Icarus, as he looks up at the sky. Or perhaps he is simply watching the crows. In the other version, he is gazing up at Icarus in flight.

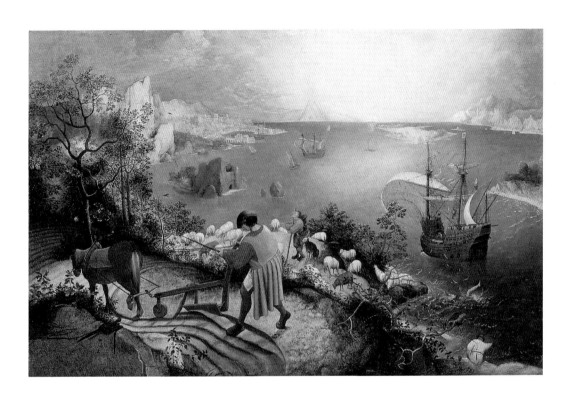

Twelve Proverbs

1558

Oil on wood, 74.5 x 98.4 cm
Museum Mayer van den Bergh, Antwerp

In the seventeenth century, these twelve wood panels were mounted into the ensemble that is now on view in Antwerp. They have been periodically attributed to Bruegel and then excluded from his oeuvre again. Nowadays their attribution to Bruegel is thought to be "undecided"; if they are by him, he probably painted them shortly before *The Netherlandish Proverbs*. The Antwerp panels certainly display numerous in features in common with *The Netherlandish Proverbs*, even if their individual subjects are here completely divorced from a broader context.

The first proverb depicts a drunkard, the second an opportunist, "who hangs his coat according to the wind," the malicious gossip (fire and water symbolizing conflict), and the glutton, who sits among what remains of his riches. The subjects of the second row are useless regret (a farmer fills a well after the calf has drowned), casting "roses [or "pearls" in English] before swine," "belling the cat," and envy: "It hurts me that the sun laughs into the water." A man who walks head first into a wall starts off the last row of proverbs; it means something like "whoever is responsible for his own misfortune feels sorry for himself." "Fishing behind the net" can be understood as a warning against wasting time and means; and he who hides under a blue coat makes his position as a cuckolded husband clear to all. The last painting in the series is dedicated to an expression found in many cultures: "to piss against the moon," meaning "to want the impossible."

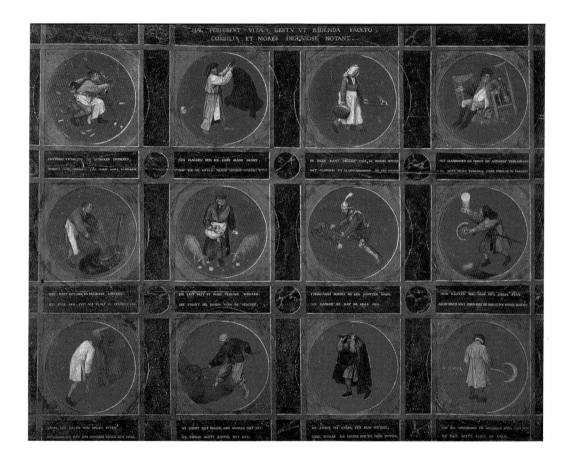

The Netherlandish Proverbs

1559

Oil on wood, 117 x 163 cm
Gemäldegalerie, Berlin

A village by a river, not far from the coast, forms the backdrop for a densely populated spectacle. The people, animals, and objects in this painting illustrate a total of more than one hundred Netherlandish proverbs and sayings. Although the scene may appear chaotic at first sight, the various characters have been carefully distributed in the pictorial space according to an overall compositional logic that allows scene after comic scene to unfold all the way to the distant horizon. But as the original title, *The Topsy-Turvy World*, makes clear, Bruegel's real focus is not specifically the humorous or moral aspect of the scene. His theme is the absurdity of human action in a godless world, a popular subject in Flemish literature of the fifteenth and sixteenth centuries. The bare-bottomed knave who sullies the globe (the world) as he relieves himself provides an unambiguous summary of Bruegel's position. The woman at the center of the composition, who has wrapped her husband in the blue coat, symbolizes infidelity. Those with power or position in society are also subject to harsh assessment: a monk attaches a fake beard to the Savior's face, while the aristocrat who makes the globe dance draws attention to the arbitrariness with which the powerful rule the world. In the confessional at the center of the painting, the Devil grants absolution to two sinners. Numerous popular sayings revolve around food: a man on a table stretches as far as he can in an attempt to grasp both loaves of bread, thus caught between two irreconcilable goals; the gruel under the table corresponds to the English saying about crying over spilled milk; and the cakes on the roof represent excess.

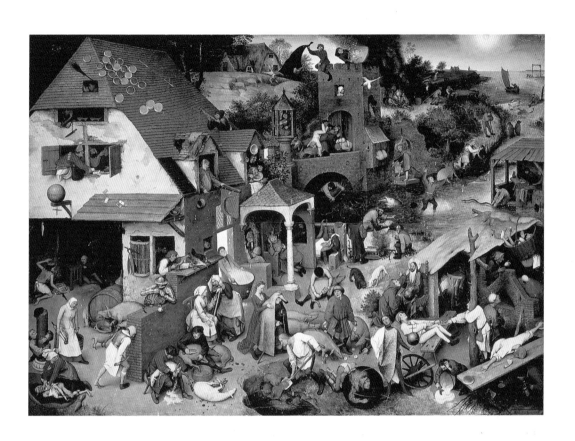

The Fight Between Carnival and Lent

1559

Oil on wood, 118 x 164.5 cm
Kunsthistorisches Museum, Vienna

From the point of view of composition, this painting is comparable to *The Neverlandish Proverbs* and *Children's Games*. One author has even argued that it is possible that these three paintings were conceived of as a group. The scenery is not dissimilar: the events take place on a lively square in a contemporary Flemish village, around which several buildings have been arranged like the scenery for a play. The subject, however, is very specific, as indicated by the title.

In the foreground, a fat man symbolizing carnival rides around on a barrel, brandishing a meat skewer as a lance. He is followed by a retinue of knaves wearing masks and playing musical instruments, as well as a figure who balances on his/her head a table with copious amounts of foods typical of this time of year.

An entirely different atmosphere reigns during Lent, which is personified by a thin, shabbily dressed female figure. She confronts her enemy with a bread paddle on which there are two meager herrings. On her head she wears a beehive, which brings to mind the traditional pre-Easter food of honey (Lent is also represented by the bread and dried figs). Lady Lent's vehicle is drawn by two people, dressed as a nun and a monk, and in her retinue are personifications of a number of good deeds: alms for the physically disabled, the poor and the blind, etc. In the background, a confrontation between the two periods—or, as some authors contend, between the Catholic and Lutheran Churches, as the former was accused of indulging in gluttony—is reenacted. While people go to confession in the church and believers step back out onto the square after the service, those in the public house enjoy themselves and drink ale. The man and woman viewed from behind at the very center of the composition are symbolic: the jester who accompanies them carries a torch, searching for carnival in broad daylight.

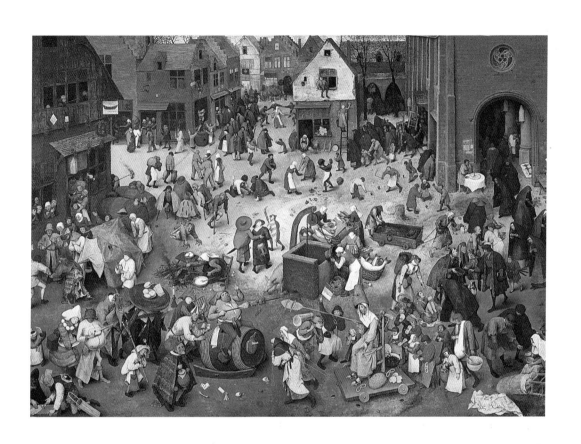

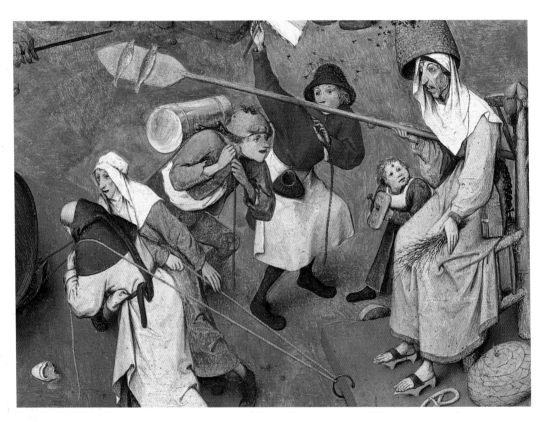

The Fight Between Carnival and Lent (details)

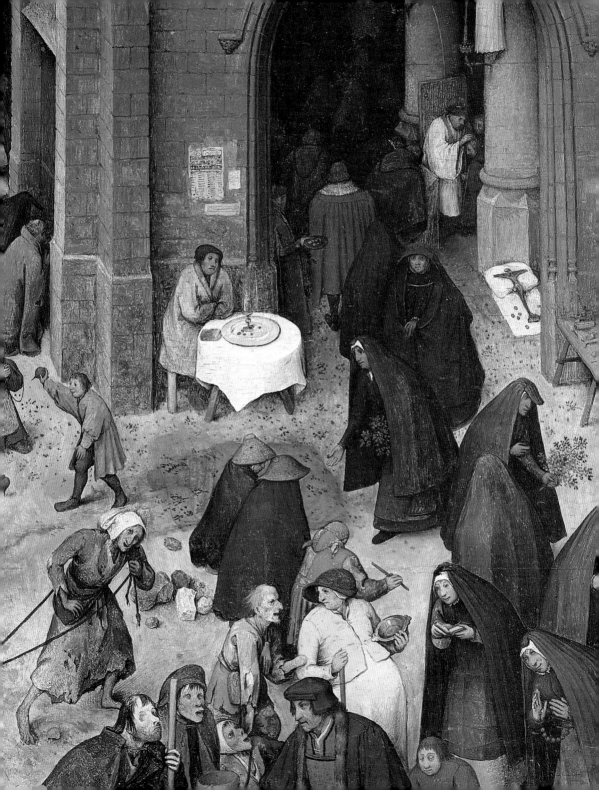

Children's Games

1560

Oil on wood, 118 x 161 cm
Kunsthistorisches Museum, Vienna

This painting constitutes one of the most comprehensive compilations of children's games ever created. Some exist to this day, while others have fallen from use entirely. All of them can be played with the small number of props available (barrels, wheels, sticks, globes, etc.). In both concept and format, this painting adheres to the scheme employed in *The Netherlandish Proverbs* and *The Fight Between Carnival and Lent*. Some critics have argued that these three paintings form an encyclopedia of precise observations of contemporary reality. And here, too, the scene is viewed from a noticeably elevated vantage point, whereby the vanishing point of the perspectival representation is shifted far to the right, the visual axis of the composition following the village's main street. Despite the large number of children—more than 230 are depicted, each engaged in either solitary or group play—they all come together to create an impression of a convincing, well-planned whole. The carefree exuberance and cheerful high spirits nowadays associated with childhood do not dominate the mood of the scene. Instead, one senses something akin to the competitiveness typical of adults in the children's expressions and actions. In their physiognomy and clothing, too, the children in the painting look like small adults, and not a single carefree smile is to be seen on any of the faces. The coloring, matching shades of brown and gray (complemented by the red and blue of the clothes) strengthens this impression, which is further heightened by the slightly unnerving fact that hardly any adults are to be seen in the village: it seems essentially to be under the control of the children. The climax of this "pretend" adult world is the bridal procession at the very center of the painting.

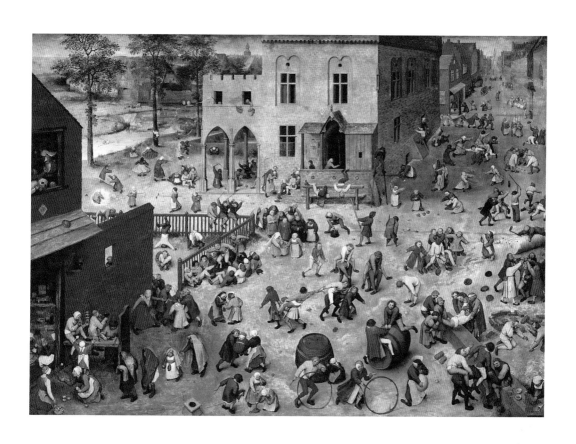

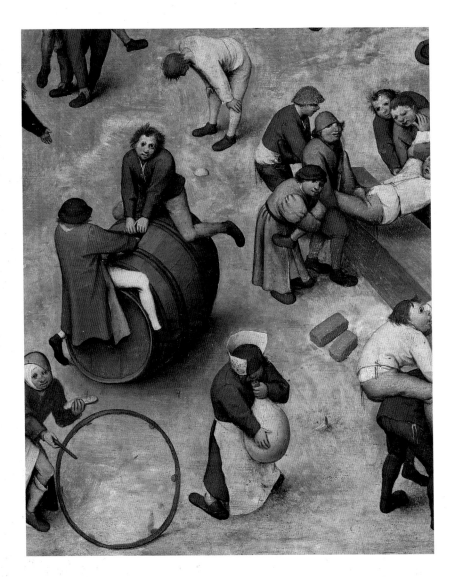

*Children's Games
(details)*

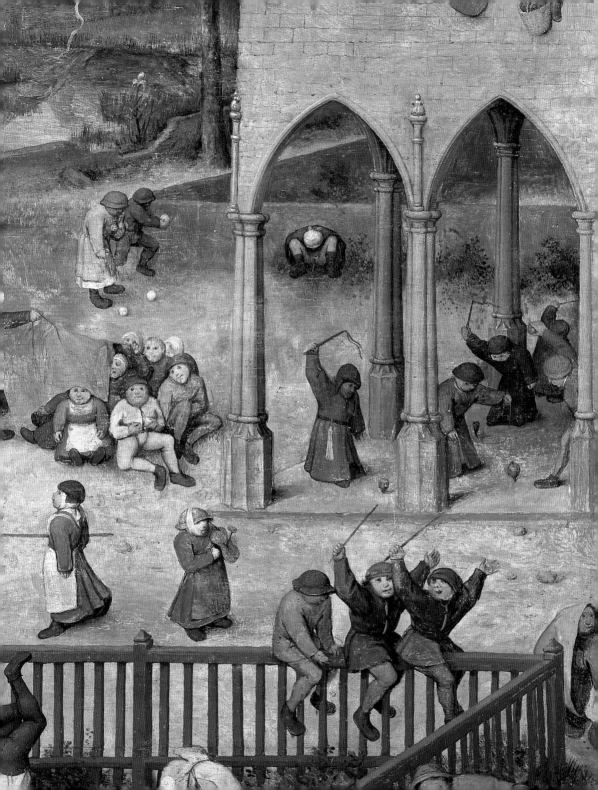

The Fall of the Rebel Angels

Oil on wood, 117 x 162 cm
Musées Royaux des Beaux-Arts, Brussels

This painting in Brussels, along with *"Dulle Griet"* (Mad Meg) and *The Triumph of Death*, constitutes part of what we can consider an imaginary triptych in which Bruegel's art comes particularly close to that of Hieronymus Bosch, whose paintings and engravings were very popular at the time. It is therefore not surprising that there was a thriving market for copies and imitation, which Bruegel himself supplied while employed in the workshop of the printer Hieronymus Cock. His adherence to his predecessor's style for several years long obscured Bruegel's own, highly original contribution to the history of art. Like Bosch, who embedded such episodes in larger iconographic contexts (as in the triptychs in the Museo Nacional del Prado in Madrid, and in the Akademie der Bildenden Künste in Vienna), Bruegel stages a veritable swarm of angels falling out of the heavens. The moment they touch the this world they are transformed into monstrous creatures of every imaginable shape and form, combining human, animal, and fantastical features. A competition for the most drastic monstrosities ensues, in which the apocalyptic dragon and the extraordinary winged being at the center of the composition dominate by virtue of their size. The task of mercilessly castigating the rebellious angels falls primarily to the Archangel Michael, who looks extremely elegant in his gilded armor, and to the two angels dressed all in white, who increase the dynamism and tension of the composition. The contrast between the sublime, celestial beauty of the angels in their wonderfully colorful robes, who populate the top section of the painting, and the thoroughly grotesque and "earthy" demons is striking.

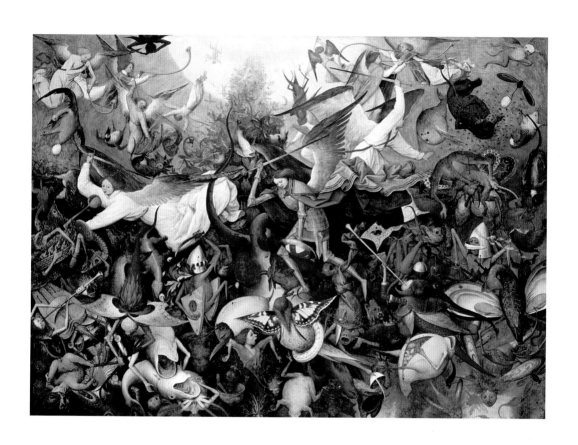

"Dulle Griet" (Mad Meg)

1562

Oil on wood, 115 x 161 cm
Museum Mayer van den Bergh, Antwerp

In this painting, the similarities between Bruegel and Bosch are particularly clear. The infernal atmosphere and the fiery coloring automatically call to mind the compositions of the great painter from 's-Hertogenbosch, which are situated on the border between that which is and that which is not rationally credible. With the exception of a few sections in the background, however, there can be no doubt that Bruegel has already gone beyond the older master's approach: his pictorial narrative features entirely new characteristics. With large strides, an enormous fury hurries towards the jaws of hell, depicted here as a tower with eyelids made of window shutters. "Dulle Griet," or "Mad Meg," is a characteristic apparition of the mythical world of Flanders. She was considered to be a personification of female perfidy, wiliness, and avarice (according to a proverb, "she could tie the devil to a pillow"). In this sense, the painting is an important precursor of the series of engravings *The Seven Deadly Sins* (1556/57). Dulle Griet carries her booty as a symbol of greed and excessive gluttony. The majority of the loot has fallen into the hands of the mob on the bridge, however. They greedily scrabble to collect the coins that are showered down on them by an egg-shaped posterior, unafraid to engage in any form of violent confrontation. All around, there is nothing but burning and devastation, demons and fantastical creatures. Here Bruegel presents such a concentration of bizarre and coded symbols (cooked chickens, broken eggs, crystal globes) that some researchers have suggested that the painting could have an alchemical meaning related to the transformation of base matter into gold.

The Triumph of Death

c. 1562

Oil on wood, 177 x 162 cm
Museo Nacional del Prado, Madrid

In a landscape dominated entirely by death and destruction, Bruegel stages one of the most popular subjects of medieval iconography: the relentless advance of death on his cart of misery and despair. Bruegel's painting immediately calls to mind its well-known Italian predecessors, such as the 14th-century frescoes by Buffalmacco in Pisa and, above all, the famous anonymous painting in Palermo (c. 1446, Palazzo Sclafani), which Bruegel may have seen on his journey through southern Italy. Like these, Bruegel's painting expresses the realization that nobody can escape the claws of death: neither men nor women, adults nor children, the rich and powerful nor the destitute, neither princes nor Church dignitaries. In the final analysis, fate holds the same end in store for all humans, and this end is generally represented in fairly stark terms in Bruegel's work. There is no point trying to escape: people irrationally attempt to save themselves by hiding from the unseeing and inexorable advance of death, in the form of a skeleton sitting on a cart drawn by a bony nag. Those who have not yet been caught flee into a type of box that bears a striking resemblance to a coffin, a trap set by the "woman in black." The couple entirely engrossed in sweet nothings in the foreground on the right appear not to have noticed yet. On the right a soldier draws his sword in a vain attempt to protect his booty, while opposite him on the left a prostrate emperor has given up the struggle. On the scorched hills all around, people are being hanged or beheaded, at sea storm-tossed ships and boats are sinking, and in the distance the inextinguishable fires of hell blaze luridly.

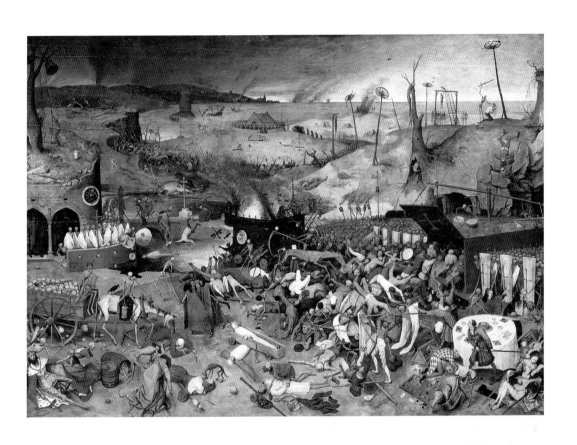

The Triumph of Death
(details)

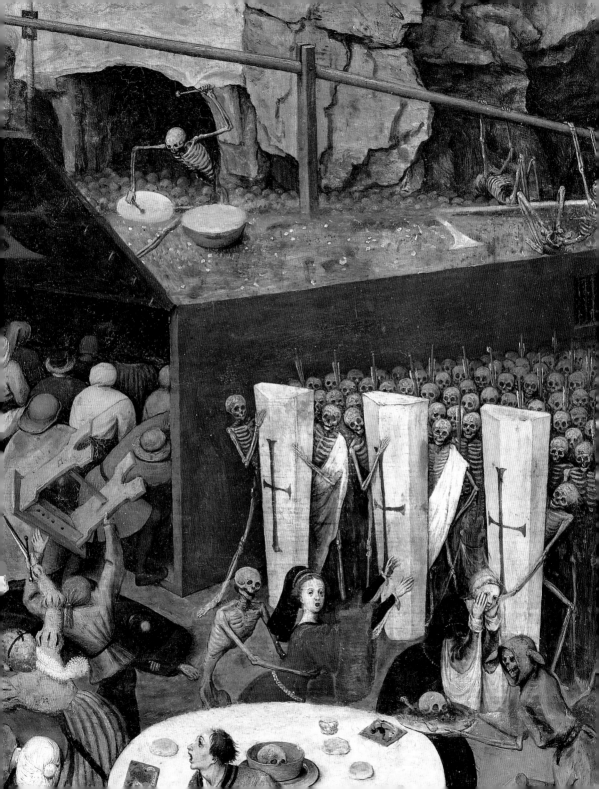

The Suicide of Saul

1562

Oil on wood, 33.5 x 55 cm
Kunsthistorisches Museum, Vienna

Often depicted as a battle between the Philistines and the Israelites, this biblical scene centers on the two people who can be seen on a rock ledge on the left. The protagonists have thus been shifted from the center of this complex, if not particularly large, composition. Saul and his armor bearer are the subject of the painting. Having been defeated, Saul has just impaled himself on his sword, and his servant is about to do the same. He does so in the nick of time: enemy soldiers are approaching. In the Old Testament story, King Saul had sinned against God in his pride. When he saw that the Philistines would certainly take Mount Gilboa, the King of Israel asked his armor bearer to kill him, but his request was refused. In the valley, the battle rages on. The soldiers' spears appear to move in waves, reminiscent of a similar effects in Albrecht Altdorfer's *The Battle of Alexander at Issus* (1529, Alte Pinakothek, Munich), which displays the same attention to miniature detail. On the rock promontory at the center of the painting the routed Israelites are being put to the sword. The background consists of green forests, a town, and high cliff from which the Israelites flee following their defeat. A fire burns in the distance. The bird's-eye view of the country-side is without doubt influenced by memories of the Alpine valleys that Bruegel saw during his journey to and from Italy. It is much less skillfully executed than the landscapes of his mature period, however, and may well have been painted by the artists in Bruegel's workshop.

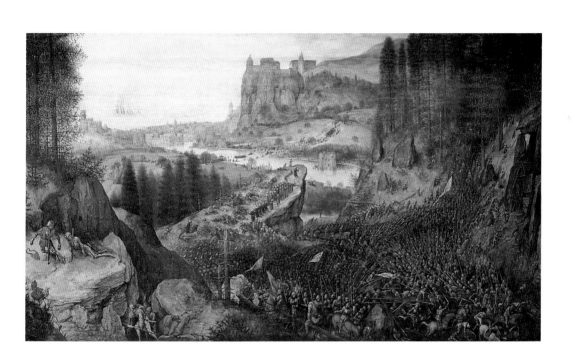

Two Monkeys

1562

Oil on wood, 20 x 23 cm
Gemäldegalerie, Berlin

It is indisputable that this painting by Bruegel draws inspiration from Albrecht Dürer's engraving *Virgin and Child with a Monkey* (1500). Bruegel, however, makes the animal itself (which also features in traditional iconography) the subject of a rather puzzling picture. In his description of the nature of the monkey, Pliny the Elder (first century AD) stated that its facial features are similar to those of humans, whom it likes to imitate. In medieval bestiaries, these animals were often associated with evil and sin, the monkey being a symbol of the baser human instincts, their antics representing the foolishness and frivolity of humankind. This view was almost certainly also current in the culture of the Netherlands in the sixteenth century.

The two monkeys with long tails are members of the rare red colobus species. They are chained to a ring in a window opening. They could be symbolic of humans, whose foolishness causes them to sacrifice their freedom to gain advantages of dubious value, symbolized by the cracked nutshells that are strewn around the animals (there is a Netherlandish saying about "running to the judge for the sake of a hazelnut"). As the view in the background shows the Scheldt estuary and the city of Antwerp, and as the picture has a small format and an intimate quality, it may be a work that alludes to Bruegel's personal situation, for at this time he was just about to leave Antwerp and to get married. A political interpretation, too, is possible: the painting could be read as a allusion to the city's lack of freedom during Spanish domination of the region, which would turn into open and cruel occupation just five years later.

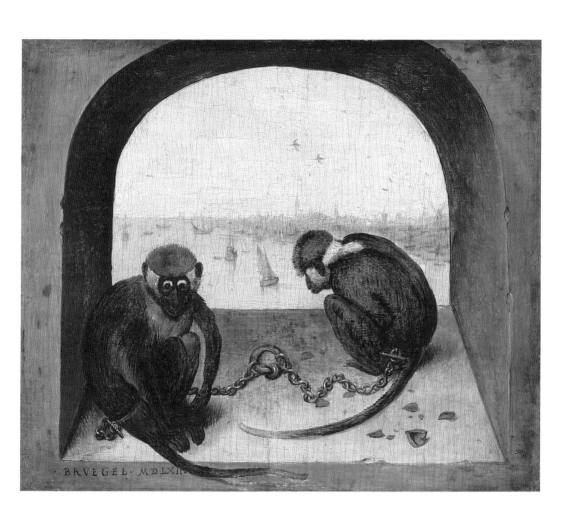

The Flight into Egypt

1563

Oil on wood, 37.2 x 55.5 cm
Courtauld Institute of Art, London

In comparison to Bruegel's "monumental" landscapes, this small composition is an example of his intimate and graceful style. It could be one of the first paintings executed after he had moved to Brussels. Historically, this painting formed part of the collection of Cardinal Perrenot de Granvelle, one of the artist's most important patrons.

Here there is no trace of the influence of Italian art; only the jagged mountain peaks (hardly a feature of the Flemish landscape) reflect his direct knowledge of Italy. In contrast, references to the work of Joachim Patinir (c. 1480–1524), possibly the most important Flemish landscape artist before Bruegel, are clearly visible both in the composition and in the approach to nature. Like Patinir, Bruegel reduces the biblical narrative to a mere pretext for a bird's-eye view of a wonderful landscape that reaches as far as the distant horizon. The staggered elements, suggesting a stage-set, heighten the illusion of spatial depth. They range from the forested hillside in the foreground to the rugged cliffs in the left middle ground, the island off the craggy coastline, and the landscape that drops off towards the horizon in the background. A landscape painting with an atmosphere such as this appears to anticipate the work of Peter Paul Rubens's (1577–1640) early period.

There are only two discernible figures in this vast landscape: Joseph leading a donkey and the Virgin Mary holding the Divine Infant, Mary's red cloak a colorful accent in a palette of shades of green, ochre, and blue. On the right, a small shrine with an overturned idol (symbolizing the pagan world) is affixed to a bare tree trunk on which two birds sit.

The Tower of Babel

1563

Oil on wood, 114 x 155 cm
Kunsthistorisches Museum, Vienna

In this painting the Tower of Babel, depicted with an impressive monumentality, has been transformed into a sublime emblem of humanity's pride, for the audacious undertaking challenged the heavens and thus incurred divine retribution. The episode depicted in the foreground illustrates this theme once more using figural representation: the stone masons fall to their knees in front of King Nimrod, who stands before them in his magnificent Oriental regalia. His doomed endeavor will have unforeseeable consequences affecting all of humanity—the confusion of languages and thus conflict among nations. The workmen occupy the vast structure like ants, busying themselves with countless activities. Bruegel has captured in minute detail both a range of machines (cranes, winches, pulleys) and also the engineering and building techniques of his time. And while work on the left side of the tower is already far advanced, workers on the side facing the river are still hard at work. The red-hued core of the structure, which juts up into the clouds, is still visible here; its form, arising out of the massive substructure, is reminiscent of the architecture of the classical period in general, and of the Colosseum in Rome in particular. Bruegel would certainly have seen this during his time in Rome, as well as depictions of it in engravings of Roman antiquities, which were already in circulation in the Netherlands at this time (Hieronymus Cock himself had published a series of such prints). The bird's-eye view allows the painter to isolate the construction of the tower and also to depict the town that surrounds it. Even a church and the defensive walls of a castle look puny when compared to the enormous tower.

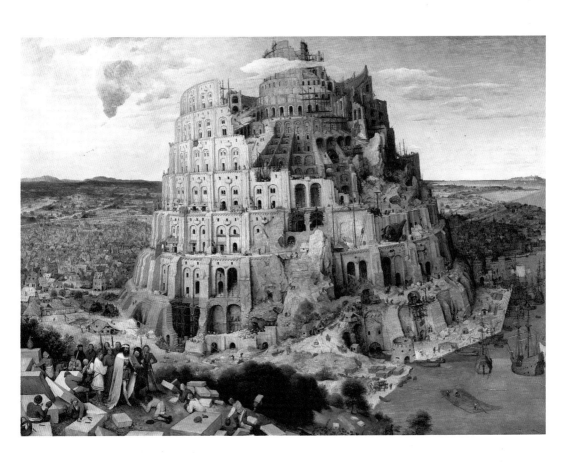

*The Tower of Babel,
Vienna version
(details)*

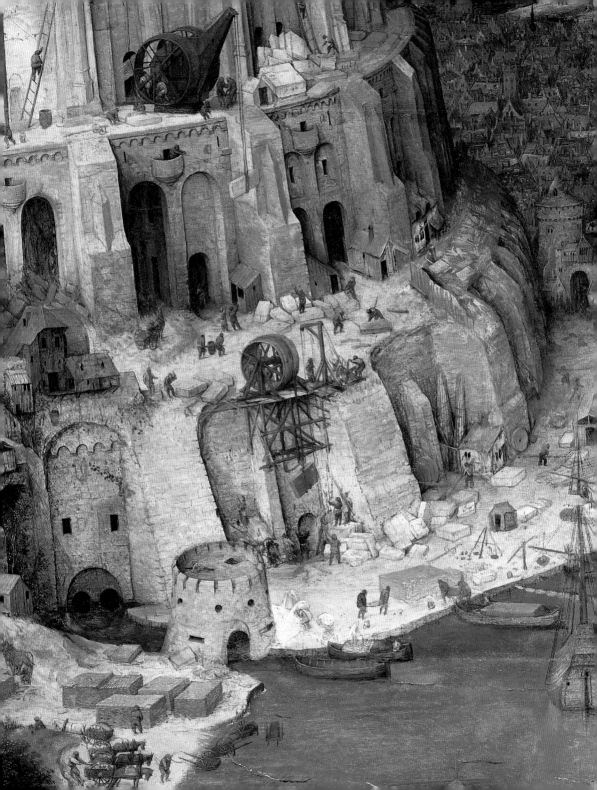

The Tower of Babel

c. 1563

Oil on wood, 60 x 74.5 cm
Museum Boijmans van Beuningen, Rotterdam

The question posed by the larger version of *The Tower of Babel* could equally to be applied to this second, smaller version: At whom is the moral of this story aimed? The answer is that it addresses all those who arrogantly believe themselves to be the creators of the world. This version is approximately half the size of the one in Vienna, and yet it communicates an even more oppressive sense of fatality in the face of the inevitable failure of the foolhardy project. Work has already been completed on some stories, but construction continues on the upper levels. Story by story, the tower reaches higher and higher until it touches the dark clouds, which looks considerably more threatening here.

The irregularities in the architectural design are also of interest: they point to the workers' inability to communicate with each other, for the confusion of languages has already set in. The overall color scheme, too, has become darker, and the delicate ocher of the Viennese version is replaced by a dark brick-red. The scene with King Nimrod has been removed from the foreground. Bruegel's depiction now focuses exclusively on the people on the spiral ramp winding around the tower. Only those who observe the painting very carefully at close quarters will notice a procession, signaled by a red canopy, where the diagonals intersect. Could this be a veiled critique of the Catholic Church? The depiction of the busy city depicted in the Viennese version is absent here, too. Instead, the viewer gazes into barren and bleak heathlands in which the only site of sporadic activity is the port.

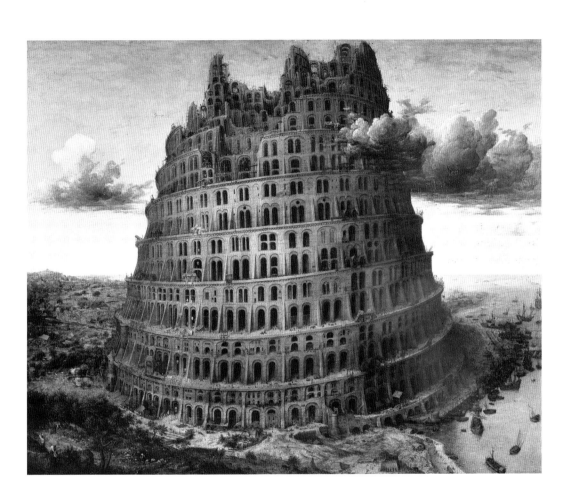

The Procession to Calvary

1564

Oil on wood, 124 x 170 cm
Kunsthistorisches Museum, Vienna

The theme of this painting is human indifference. All of the figures in the composition share, to a greater or lesser degree, an insensibility to the dramatic events unfolding before their eyes, their sole desire being to satisfy their curiosity about the bloody spectacle. Though more than 500 figures populate this painting, the composition is not confusing. It is possible to discern a procession, marked out by the series of guards dressed in striking red, despite the fact that it does not proceed in an orderly manner. And on the way from Jerusalem to Golgotha, the landscape becomes increasingly somber.

The pictorial narrative focuses on three "emotional" focal points. The primary event occurs at the very center of the composition, though it is almost invisible: Christ collapses under the weight of the cross. Just to the right, a cart carries the two thieves. Bruegel has positioned the group around Simon of Cyrene, who is depicted as he meets the soldiers who want him to bear Jesus's cross, in the left middle ground. The mourners are in the foreground: Mary, St. John, Mary Magdalene, and others. In dress, they are clearly distinct from the people in the background, their depiction following Flemish traditions deriving from Rogier van der Weyden (1399/1400–1464) and Hugo van der Goes (c. 1440–1482/83). They alone experience pain at the impending death of their loved one, constituting a picture within a picture characterized by a poignant sense of intimacy. In the background, we can see the crowds flocking towards the execution ground in a circle on the right. Strangely, a windmill stands on a high, jagged cliff on the left. The painter's self-portrait has been read into the man whose profile is just visible near the right-hand edge of the painting.

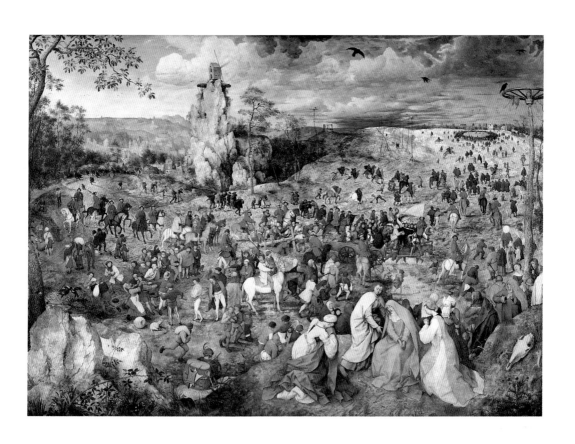

The Adoration of the Kings

1564

Oil on wood, 111 x 83.5 cm
National Gallery, London

With the exception of his collaboration on the lost retable in Mechelen, Bruegel appears not
to have created any religious paintings specifically for churches. The historical situation
was not exactly ideal for such commissions: in 1566, followers of Martin Luther destroyed
artworks and churches in the spirit of fierce iconoclasm. A few *grisailles* aside, the painter
preferred to embed biblical scenes in larger narrative contexts that required a different
understanding of art and were aimed at a better-educated clientele that was largely, though
not exclusively, composed of lay people. This large-format panel painting, on which his
figures for the first time achieve a kind of monumentality, is an exception to this rule. The
scene depicted is very well known: the Adoration of the Kings, transmitted by the Gospel of
Matthew and, more importantly, by the Apocrypha and later legends of the saints. Aspects
of color, composition, and the figures are vaguely reminiscent of Italian predecessors.
Simultaneously, however, numerous characteristics anchor this painting to a "realistic"
tradition typical of Flanders. These include the unrefined appearances of the two older
kings with their crumpled faces and sparse, messy hair; the dominance of the gigantic
African king on the right (younger and far more prepossessing than the other figures);
and the dim-witted people surrounding them (of which the most notable example is the
bespectacled man on the far right, whose spectacles have been interpreted as a symbol of
his "inability to see" the significance of the events unfolding before him). The treatment of
the protagonists, too, is subject to a form of "desacralization": the Virgin Mary's face is
half-obscured, and the Divine Infant is not portrayed as a graceful child. The young man
whispering in Joseph's ear, too, is noteworthy. He is probably sowing doubts about Mary's
supposed virginity, according to a fairly widespread apocryphal tradition.

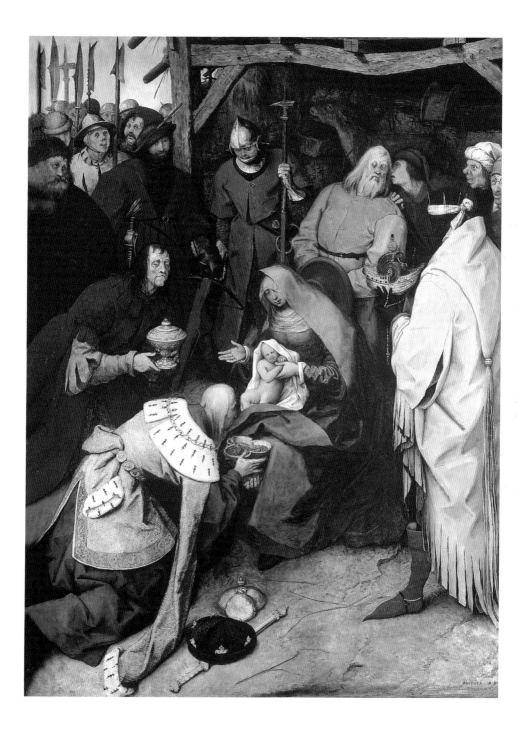

The Death of the Virgin

c. 1564

Grisaille on wood, 36 x 55 cm
Upton House (Banbury), National Trust, Britain

This highly original *grisaille* was painted by Bruegel for his friend Abraham Ortelius (1527–1598), who commissioned Philipp Galle to engrave it. Scholars have repeatedly cast doubt on the attribution of this work to Bruegel, and the modernity of this nighttime scene, which feels almost like a precursor to the works of Rembrandt, is astonishing.

Bruegel depicts the death of the Virgin Mary according to the *Legenda Aurea* (Golden Legend) of Jacobus de Voragine (c. 1230–1298), a comprehensive collection of the legends of saints that supplied the artists of the time with a rich fund of information and ideas. As she dies, Mary is surrounded by the Apostles, who add particular appeal to this composition. The followers of Jesus, who have already dispersed to all parts of the world to spread the Word, have arrived on clouds at the place where the Mother of God will die (or, according to some traditions, "fall asleep"). Bruegel adds saints, Fathers of the Church, and martyrs to the scene, making it a fairly densely populated composition. John the Evangelist is separated from the other figures surrounding Mary's bed. He has dreamt of this event, and so Bruegel depicts him sleeping. The realism with which Bruegel has painted the cat cowering by the lit fire is remarkable. There are numerous sources of light in this painting, such as the fireplace and the candle, but the light underneath the canopy cannot be explained by the candle held by St. Peter. The light that shines here is supernatural. The Mother will now return to her Son, an image of whom (on the Cross) leans against a pillow set at the bottom of the bed.

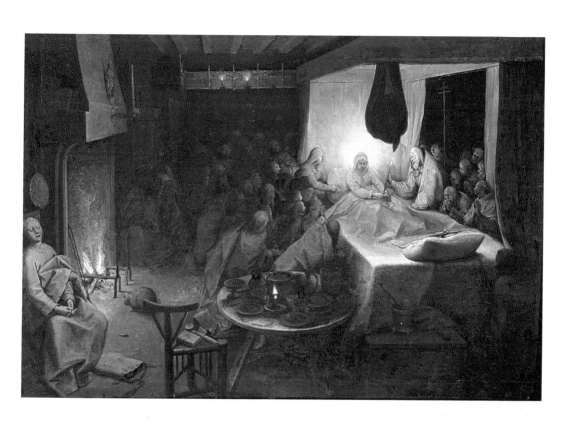

The Massacre of the Innocents

c. 1564

Oil on wood, 109.2 x 154.9 cm
Hampton Court, Royal Collection, Britain

Numerous versions and copies of this subject exist, including a famous copy in the Kunst-historisches Museum in Vienna, attributed to Pieter Brueghel the Younger, which has the same dimensions as this panel. Which of the two should be attributed to Bruegel was once the subject of keen debate; the dating of the work continues to exercise authorities, for a date of 1567 would allow it to be seen as alluding to the harsh treatment to which Flanders was subjected under the Spanish occupation; in some instances, the rider dressed in black at the head of a troop of soldiers at the center of the painting, blocking any attempt at escape from the village, has been identified as the Duke of Alba. Herod's soldiers are not deterred from carrying out the massacre of the children by the desperate pleading of the women and men. They murder the children on the spot, enter the houses in search of hidden infants, and interrogate the mothers with brute force. What is unique about this painting is that the harshest details—in other words the wounds on bodies of the children—have been painted over in order to tone down the starkness of the depiction. Bruegel has chosen a village in Brabant, with a church and a public house, as the setting for this biblical scene. The snow, which in *The Hunters in the Snow* suggests a calm and muted atmosphere, is here an infernal slush. The bare trees and leaden sky contribute to the suffocating atmosphere and sense of remorselessness. An event that took place in the distant past is transposed into a dramatic present that was undergoing rapid religious and political change.

Christic and the Woman Taken in Adultery

1565

Grisaille on wood, 24.1 x 34 cm
Courtauld Institute of Art, London

In addition to *The Death of the Virgin* at Upton House in Banbury, two *grisailles* by Bruegel are known: this painting and *The Three Soldiers* (1568, Frick Collection, New York). It should also be noted that he used the same technique to paint the saints on the side panels of the retable of Mechelen in collaboration with Pieter Balten (c. 1525–1584) during the earliest period of his career. The attribution of this panel to Bruegel has been disputed periodically, for it is sometimes thought to be a copy of a lost original. It is interesting that the original painting was left to Cardinal Federico Borromeo by Jan Brueghel, Bruegel's younger son. The prelate commissioned a copy and then gave the original back to the family.

Christ, who is kneeling, writes in the dust the words recorded in the Gospels, in Dutch: "Die sonder sonde is / die..." ("Let him who is without sin [cast the first stone]). While in the majority of Bruegel's works the influence of Italian art is difficult to discern, here commentators have been a little more successful. A connection can certainly be established between figures by Raphael and a number of Mannerists, and the figure of the woman caught in adultery and some of the bystanders, who drop their stones or lean forward skeptically. Bruegel emphasizes the beauty of the young woman, who looks reserved and slightly aloof. She is without doubt one of the most fascinating women in Bruegel's oeuvre, as most of them, to put it bluntly, are strapping peasant women. The painterly treatment with fine gradations of gray and a few dots of brown adds to an impression of monumentality in what is actually a relatively small panel.

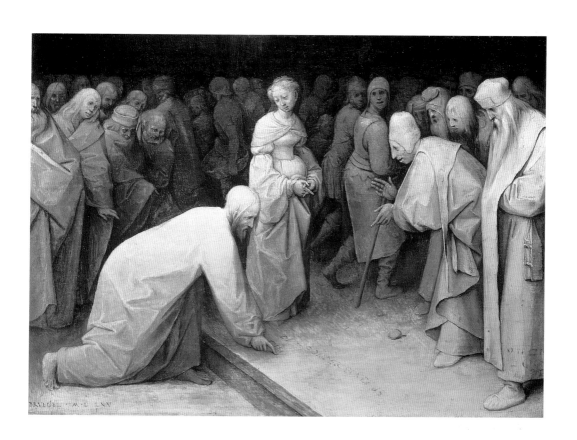

The Gloomy Day (February–March / Early Spring)

1565

Oil on wood, 118 x 163 cm
Kunsthistorisches Museum, Vienna

We now tend to begin Bruegel's Season Cycle with this painting, and its season (early spring)
is sometimes indicated alongside its traditional name (*The Gloomy Day*). In the foreground,
a farmer cuts osiers (a task performed in February) while a companion gathers them
together into bundles. To the right is a family group; a man eats a waffle like the ones
traditionally eaten during the carnival period, and a child wearing a paper crown holds a
large lantern. From the elevated position, a magnificent view of the vast landscape opens up
to the left, ending with snow-covered mountain peaks in the background. Life in the village
appears to proceed at a leisurely pace, except in the tavern, where a boisterous celebration
is underway. The houses are all tinted with the gloomy light of a leaden, threatening winter
sky, as though it has just stopped raining. This is reflected in the river, too, where boats navi-
gate the waves with some difficulty. The mountains are covered with a thin layer of fresh snow.
This painting abounds with suggestions of the insignificance of humanity and the vastness
of nature. Constant effort is needed to keep body and soul together; on the right, a man
repairs the roof of his house, while in the village, another sifts corn and a woman weeds a
vegetable patch. Some commentators see a special significance in the delicate branches of
the group of trees at the center of the painting, which jut up towards the sky in front of the
buildings, thus linking earth and water, mountains and clouds.

The Hay Harvest (June–July / Early Summer)

1565

Oil on wood, 117 x 161 cm
Private collection

The painting depicting spring has, unfortunately, been lost. The third work in the Seasons Cycle is dedicated to the months of May and June according to some scholars, and to June and July according to others. The traditional title of the painting is *The Hay Harvest* (after the heavily laden hay cart in the valley). This is the most relaxed time of year, the weeks during which humanity is in total harmony with nature, even if strenuous work has to be done. When considered alongside the four other extant paintings in this series, this one stands out for the gentleness of the soft, golden light that bathes the scene. It is certainly one of the most cheerful works in Bruegel's oeuvre. The countryside, painted using *sfumato* (the soft blending of colors), is seen from the bird's-eye perspective typical of the artist. The foreground is peopled by two groups of walking figures and by a seated figure on the left who is sharpening a scythe. One group is on its way into the valley, the figures carrying baskets full of cherries and strawberries on their heads. They are accompanied by a peasant woman on horseback, her red doublet adding a wonderful dash of color to a painting whose color scheme is otherwise limited almost entirely to shades of green, blue, and ochre. The group of three peasant women in the foreground who walk towards the left is even more fascinating. One of them appears to look straight at the viewer. They do not display any of the dimness that characterizes the rest of Bruegel's peasant figures. The painting was in the collection of the National Gallery in Prague, but was returned to a private collection in 1992.

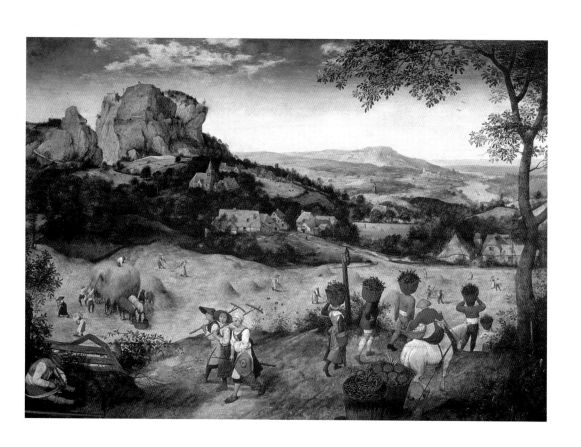

The Harvesters (August–September / Summer)

1565

Oil on wood, 119 x 162 cm
The Metropolitan Museum of Art, New York

The bright yellow of the months of July–August (or August–September) dominates this painting from the Seasons Cycle. The landscape is once again depicted from a bird's-eye view, with the vertical axis of a large tree anchoring the composition on the right. Virtually all of the painting's lines converge here: the sheaves of corn on the ground and the bundles on which the peasants sit, as well as the compositional lines created by the broader landscape. Geometrically, the painting appears to be divided into two parts. In the lower section, the vibrant warm colors of the corn dominate, whereas in the upper section, where the branches of the tree separates the nearby landscape (including a church with blue-tinged tiles and a clock tower) from the open countryside on the left, cooler colors prevail. One author claims that the body of water in the background is reminiscent of Lake Geneva, which Bruegel may have seen during his trip to Italy. The human figures, too, appear to be separated into two categories. There are those who use their scythes to mow and create paths through the "walls" of tall, ripe grain and bundle together the cut sheaths; and those who rest in the shade of the tree to eat and drink. It is this intimate genre scene that forms the focus of the painting. One man has already lain down for a midday nap, his pose, with splayed legs, distinctly reminiscent of that of the cleric in *The Land of Cockaigne*.

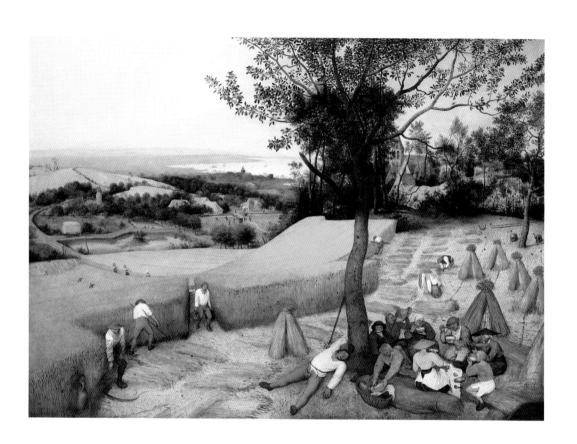

The Return of the Herd (October–November / Autumn)

1565

Oil on wood, 117 x 159 cm
Kunsthistorisches Museum, Vienna

As with the other paintings in the series representing the various times of year, it is difficult to assign two specific months to this one definitively, though it is generally assumed that it refers to the months of October and November. The autumnal mood is clearly reflected in the color scheme, which is centered on a rich spectrum of ochre and earth tones. The contrast between these colors and the cold blue tones of the river, mountain landscape, and sky is memorable, and provides a foretaste of the season that will follow. The stated subject of the painting (*The Return of the Herd*) unfolds in the foreground, along a diagonal running from right to left that is mirrored by the course of the river in the middle ground. As critics have pointed out, the compositional rhythm, which ascends laboriously towards the left, is unusual for Bruegel, who otherwise prefers a descending movement. As in so many of his compositions, the nearness of the foreground allows the viewer to enter the scene imaginatively. Accompanied by a rider and three other men, the animals are prodded and guided by two herders into moving, reluctantly, towards the village. With the exception of a white cow in the foreground, the coloring of the herd melds harmoniously with the landscape, as indeed does that of the people in the painting, too, echoing the basic tint of the animals, foliage, and earth.

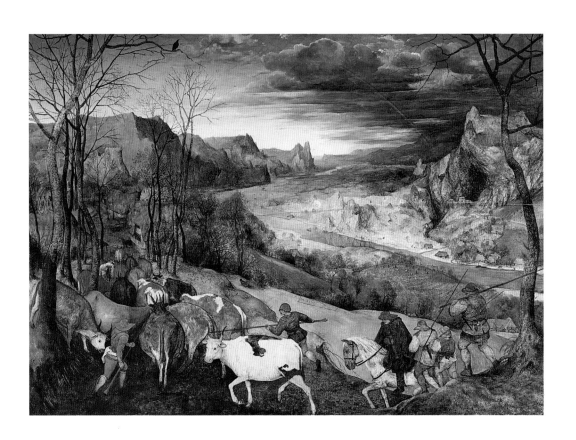

The Return of the Herd
(details)

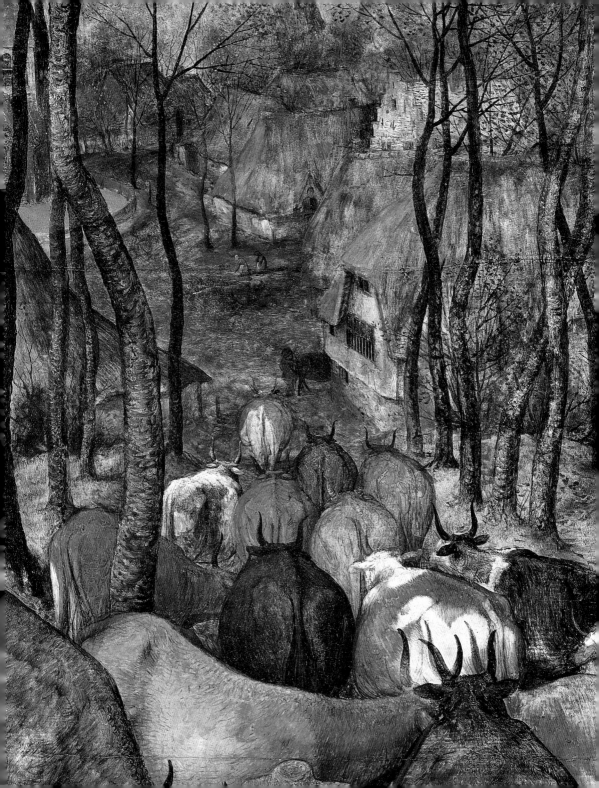

The Hunters in the Snow (December–January / Winter)

1565

Oil on wood, 117 x 162 cm
Kunsthistorisches Museum, Vienna

One of the best-loved works by Bruegel, this is undoubtedly the best-known image of winter in Western art. It was once considered a prelude to the Seasons Cycle, but in reality this painting forms its magnificent conclusion. Never before had a painter managed to create such a convincing representation of the coldness, the silence, and the torpor of the winter landscape. The mood is created by the dominance of the white of the snow and the gray-green of the sky and stretches of frozen water. The construction of pictorial space is both convincing and fascinating. The row of trees that recedes from the foreground into the background forms the main, descending line, and is echoed by the slow movement of the dogs and men, who return with little game; leaving deep prints in the snow, the dogs walk with lowered heads and with their tails between their legs. Following the direction of the hunters, the viewer's gaze travels diagonally from left to right across an expansive landscape of frozen lakes and tiny hamlets to the mountains in the distance. Even during the coldest months of the year, men and women continue to work away busily. Some are engaged in practical tasks (a pig is being singed on the left, outside a tavern), others are relaxing on the ice, playing hockey, sledging, or skating. Carefully observed and beautifully depicted, the snow creates a sense of complete suspension, of nature lying dormant as man struggles to stay alive.

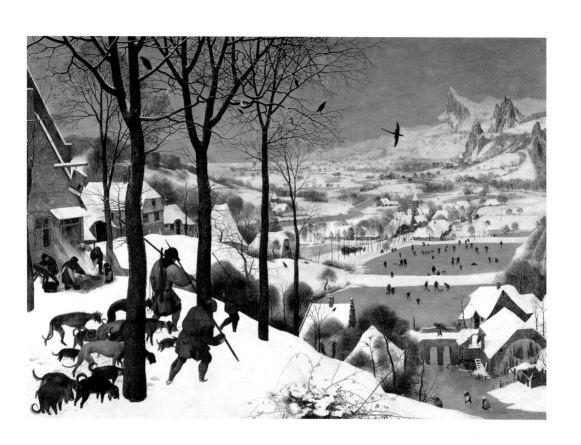

The Hunters in the Snow (details)

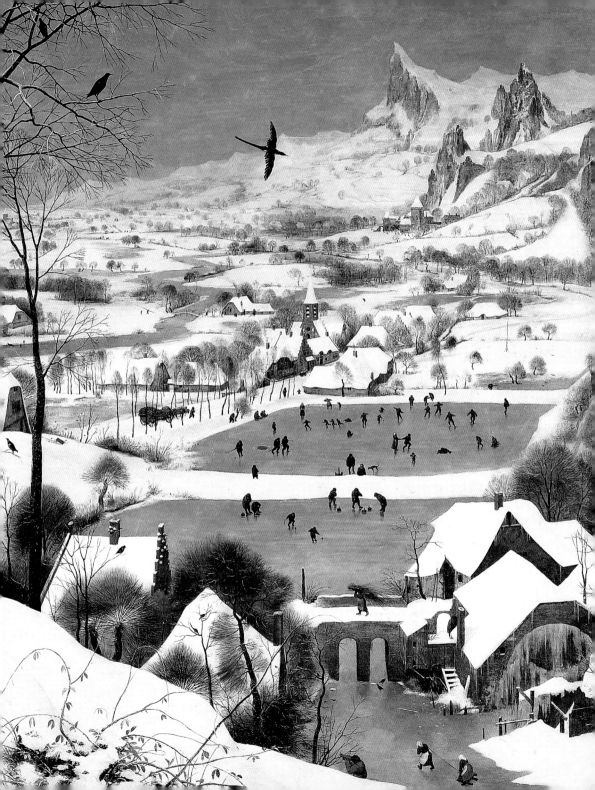

Winter Landscape with a Bird Trap

1565

Oil on wood, 37 x 55.5 cm
Musées Royaux des Beaux-Arts, Brussels

This small-format painting, which arouses less enthusiasm today than the views in the Seasons Cycle, was a great success at the time of its creation and continued to be very popular, as shown by the existence of numerous copies (there are at least sixty). The representation of winter landscapes is a defining element of Bruegel's oeuvre, with *The Hunters in the Snow* and *The Adoration of the Magi in the Snow* marking the pinnacle of his achievement.

This winter landscape was executed in the same year as the great Seasons Cycle, and it is entirely possible that it is a direct reference to the particularly harsh winter of 1564/65. According to the critical literature, this is not just a genre scene, but a moral allegory. Numerous cues point to this interpretation, starting with the observation that there are only two forms of life in this painting: people and birds, who share a common fate. Just as the birds are at risk of losing their lives in the trap that has been set for them, the humans while away the long, cold winter days playing games on ice, unaware of the dangers lying in wait. A number of commentators have observed that the size of some of the ravens in the painting, particularly the bird on the top right and the two birds whose silhouettes are marked out against the ice, is equal to that of the humans. For a long time, it was assumed that Bruegel had depicted a real place, Sint-Anna-Pede, but it has not been possible to confirm this.

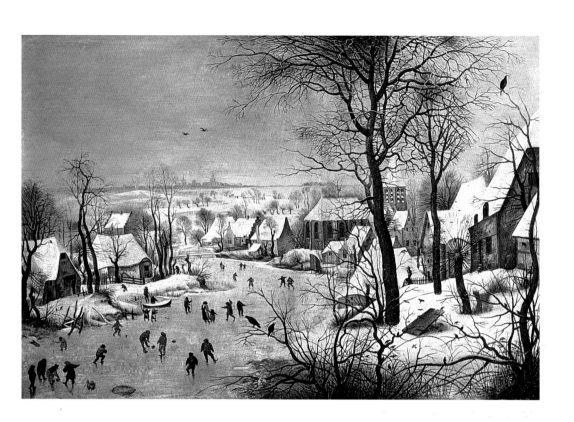

The Census at Bethlehem

1566

Oil on wood, 115.5 x 163.5 cm
Musées Royaux des Beaux-Arts, Brussels

This painting, which is also known as _The Numbering at Bethlehem_, is a classic example of Bruegel's compositional technique of embedding biblical stories in relatively mundane surroundings rather than drawing attention to them. In the foreground, Mary appears on a donkey as though by chance, one among many. She is wrapped in a wide blue cloak and is accompanied by Joseph, who has slung a large saw over his shoulder and is leading an ox. They are on their way to the tavern "The Green Wreath," where people have gathered in order to be recorded in the imperial census. In this way, the biblical narrative (Luke 2: 1–5) is transformed into an opportunity to depict an imaginary Bethlehem located in Flanders. Despite the harsh winter conditions, life goes on. A pig is being slaughtered outside the tavern, to which large wine or ale barrels have just been delivered; both food and drink will be needed to satisfy the large number of people who have come for the census. In the middle ground, people can be seen playing and competing with each other on the ice. A decrepit hut is of particular interest, however. It is marked with a cross and can be seen as the stable in the Nativity story. A few men warm themselves by a fire, while others have taken shelter in a large, hollow tree trunk. Others still are building a wooden hut. Further away, we can see a slightly shabby looking little town with towers and town walls. The atmospheric concentration of the depiction reaches its climax in the scenery that forms the background on the left, where behind a tangle of bare branches the faint sphere of the sun peeps through.

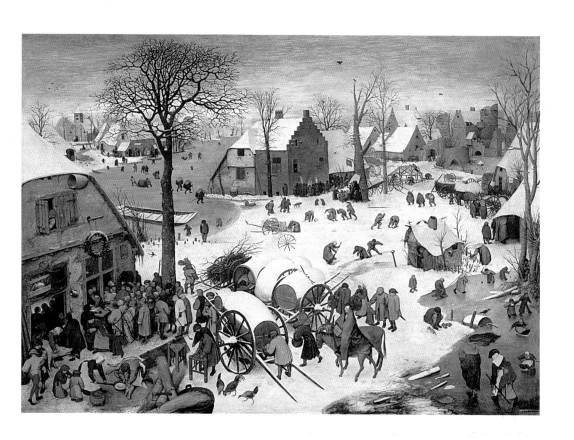

The Sermon of John the Baptist

1566

Oil on wood, 95 x 160.5 cm
Szépművészeti Múzeum, Budapest

Some scholars see a direct connection between this densely populated composition and the
Protestant practice of holding religious meetings outdoors at which Catholic doctrine was
criticized in long sermons. Almost all faces are turned towards John the Baptist, who wears
a simple, brown robe and uses expansive gestures to show the people the right path: the
path to Christ, who is in a less prominent position but easily recognized by his light hair and
blue robe. Many emotional reactions are betrayed by the faces of those gathered to hear
him speak, ranging from consternation and incredulous astonishment to indifference and
enthusiastic engagement. We see a truly heterogeneous crowd of people, in the depiction
of which Bruegel must have drawn inspiration from everyday life. The figures in the
foreground clearly stand out from this group. They wear magnificent striped Oriental
gowns, and on the left there is even a Muslim wearing a turban. One of them, a gypsy, is
visibly unmoved by the Christian sermon as he reads the fortune of a bearded man. It
should be noted that these two people are on the same vertical pictorial axis as Jesus.
Neither they, nor the two men along the right-hand edge of the painting, show the least
interest in the sermon. Are they the enemies of the true faith? Some commentators have
identified two figures who might be self-portraits of the artist: the bearded man between
the two standing figures in the foreground, and the bearded man on the far right (who may
be accompanied by his wife and mother-in-law). A view of a broad river-landscape,
presumably a reference to the River Jordan, opens up between the crowd of people and the
tree trunk on the right.

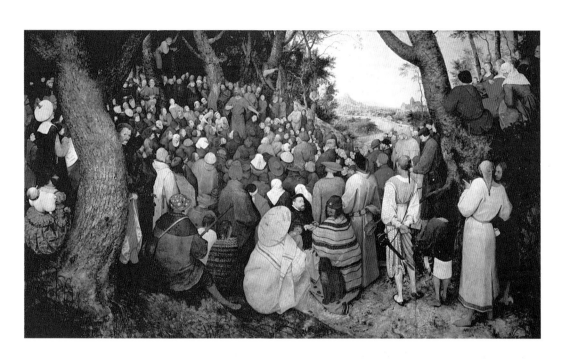

The Wedding Dance

1566

Oil on wood, 119 x 157 cm
Institute of Arts, Detroit

This is the first known composition in which Bruegel depicts a peasant wedding. Such paintings became a fixed part of Flemish painting, and in the face of countless replicas and variations it is not always possible to determine which were actually painted by Bruegel himself. The painting teems with people (more than 125 are depicted) and yet the scene gives the impression of a convincing and well-planned composition. In the background we can see the wedding banquet, served in front of a cloth to which the bridal wreath has been attached. The bride has left the table (she may be the woman dancing in the center of the painting, the only person not to have covered her head). The action becomes increasingly lively towards the front of the painting, as the enthusiasm with which the peasants abandon themselves to their country dances is heightened. Two of them hold each other as they kiss, contributing to the general mood of the scene. As scholars have repeatedly pointed out, this representation is characterized by a number of traits that were at the time ascribed to peasants and the common people, notably simple-mindedness, gluttony, and lasciviousness—the men in the foreground do not hide how much they enjoy the physical contact with the women. There is just one exception: the mysterious figure that completes the composition on the left. The man dressed in black could be a reference to the wise man who regards these traditional, all-too-human enjoyments with a certain detachment. This (possibly moralizing) role is not the focus of contemporary scholarship, however, which tends to interpret the painting as a record of folk customs executed with the greatest artistic skill. The under drawing of a number of the figures have become visible as a result of the comparatively bad condition of the painting, some of the paint having worn off.

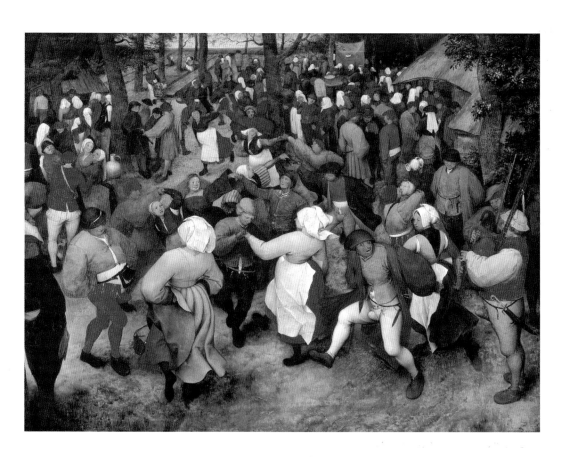

The Conversion of Paul

1567

Oil on wood, 108 x 156 cm
Kunsthistorisches Museum, Vienna

Here the stated subject is far less conspicuous than in most of Bruegel's religious works; indeed, it is barely visible. The viewer's attention is drawn first to the magnificent landscape, with its Alpine gorges and cliffs and majestic mountain forest. Although it takes place almost exactly at the intersection of the diagonal axes, the conversion of Saul (later known as Paul), by contrast, is little more than a narrative detail in a turbulent scene in which foot soldiers and riders travel towards a destination not shown in the painting: the distant city of Damascus. The soldiers and baggage wind their way up through the valley on the left towards the gorge on the right-hand edge of the painting. The incident in which Saul, struck by divine light, falls from his horse, provides only a brief interruption. His blue robe and the empty space that has opened up remove him—as if by accident—from the procession of advancing soldiers. In the foreground, by contrast, our attention is drawn to two finely depicted riders, in particular to the one in the yellow cloak, who represents a small masterpiece of draftsman-ship and color. It is difficult to provide a generally accepted and convincing interpretation of this painting, which was executed in the year before the Spanish reign of terror began. One author identifies the black-cloaked rider as the "terrible" Spanish governor of the Nether-lands, the Duke of Alba, but this is not convincing. According to another interpretation, the painting could simply be symbolic of the struggles of men and women to achieve their own goals, which are often as remote and inaccessible as the mountains the soldiers are struggle to ascend, and which frequently have little to do with spiritual needs.

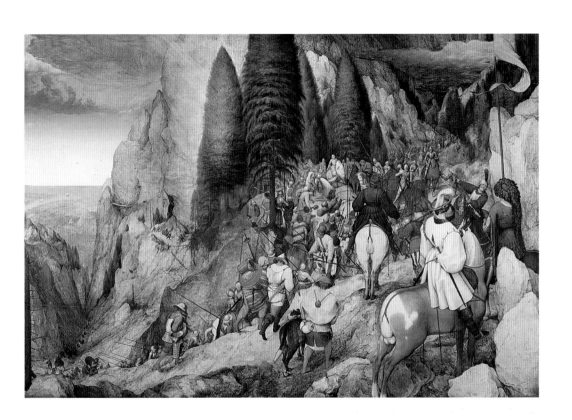

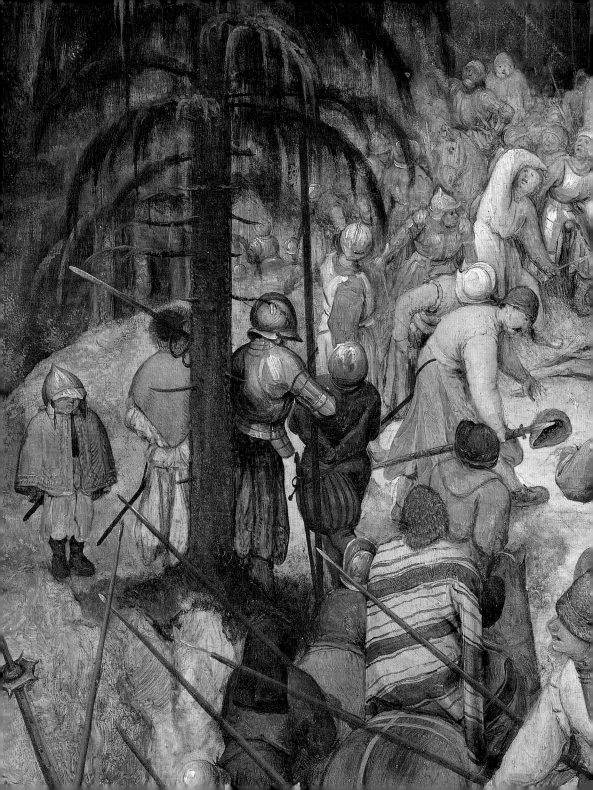

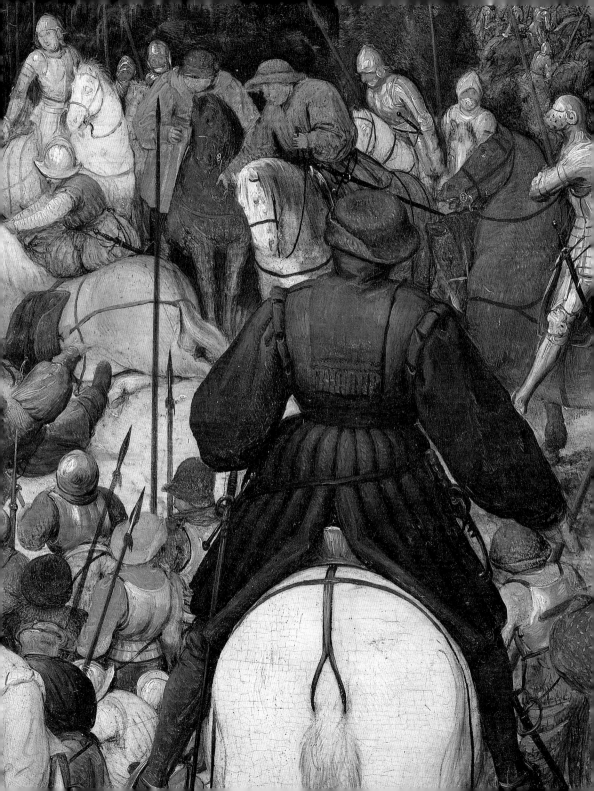

The Adoration of the Magi in the Snow

1567

Oil on wood, 35 x 55 cm
Oskar Reinhart Collection "Am Römerholz," Winterthur

Here a biblical story is illustrated on the left in an audacious composition that almost detracts from the overall impression of the painting. This is not the artist's first depiction of the subject. In the London version, *The Adoration of the Kings* (1564, National Gallery), the main action occupies the center of the composition, whereas here it is essentially treated as a mere pretext to paint a Flemish village on a harsh winter's day, covered by snow that continues to fall. The treatment of the snowflakes, probably the first representation in the history of art of this atmospheric phenomenon that is so difficult to capture, is remarkable (as other artists had discovered, painting falling snow is much harder than one might expect). Unimpressed by the biblical event and its significance for the fate of humanity, everyday life continues as usual in the village, as though this day were no different from any other. The adults trudge through the snow, while the children take advantage of the frozen waterways to have fun with their sledges. And yet a small crowd of people and animals has gathered where the holy event is taking place. In the hut, heavily weighed down by the snow, two of the three Wise Men kneel to pray in front of the Infant Jesus. Joseph can only just be discerned as he stands deep inside the building. A large Romanesque building (perhaps a castle or a church) provides a compositional counterweight, an anachronism popular at the time among painters, who used the architecture of their world as models for imposing structures such as these.

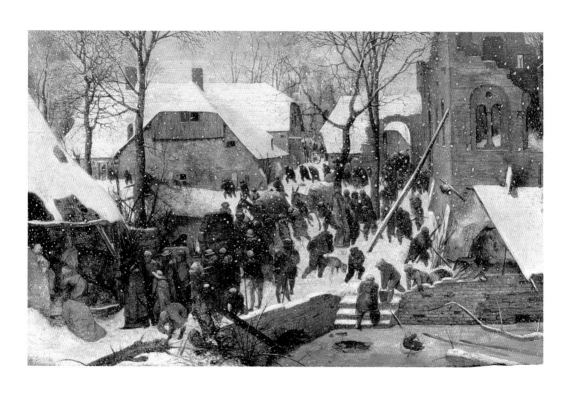

The Land of Cockaigne

1567

Oil on wood, 52 x 78 cm
Alte Pinakothek, Munich

In the Netherlands, the Land of Cockaigne was called "Luilekkerland": an imaginary place where all pleasures are allowed and are readily available. It is reached via a passageway that leads through a mound of grain (shown on the right), and in this magical place various foods offer themselves up to be eaten. The "cactus" on the right consists of slices of pie, a knife has already been stuck into the side of the pig, a roasted chicken presents itself on a plate, and a boiled egg walks over on its own two legs, bringing cutlery with it; the fences are made of interwoven sausages. The soldier underneath the roof of the hut has nothing more pressing to do than to wait for the roasted pigeon to fly into his mouth (not shown here), or for the cakes to fall into his gullet. Similarly, the three men under the tree are accustomed to eating delicacies without interruption, their fat, listless bodies clearly displaying their gluttony. They represent the three estates: the soldier with his lance, the peasant with his flail, and the cleric with the attributes of scholarship. It is hard to say whether the painting is related to the famines that ravaged the land repeatedly, or whether it was intended as a warning not to abandon oneself to gluttony and sloth while ignoring moral values; probably both readings apply simultaneously. The construction of pictorial space is striking, with the tree at the center forming an axis from which the three main figures radiate outwards like the spokes of a wheel.

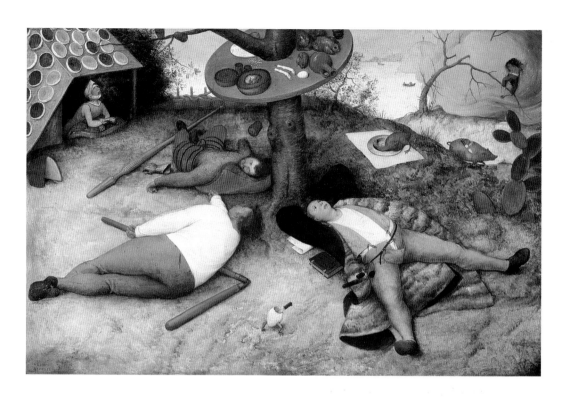

The Beggars (The Cripples)

1568

*Oil on wood, 18.5 x 21.5 cm
Musée du Louvre, Paris*

This small-scale painting deals with a subject that we have already encountered in Bruegel's oeuvre; he depicted disabled and blind people both as subsidiary figures in larger compositions (in *The Fight Between Carnival and Lent*, in *The Netherlandish Proverbs*, and in *The Sermon of John the Baptist*) and as independent subjects (in *The Blind Leading the Blind* and in several drawings). In this particular painting, the subject acquires a dimension that could be described as monumental, despite the small dimensions of the panel. The manner in which these five men are represented reveals a high degree of empathy, even though at the time they were widely associated with negative attributes (those with physical disabilities were commonly considered to be thieves or cheats). A woman walks away from the group, carrying a bowl. Perhaps she brought them something to eat: disabled people were dependent on charity such as this because they were unable to earn a living. Two of them (those without legs) whisper to each other, another is cross-eyed, while the fourth (on the right, and viewed from behind) follows the woman with his eyes, and the last (also seen from behind) looks at an opening in a high wall to the trees beyond. Scholars have been particularly interested in the foxes' tails attached to the beggars' clothes. This was the traditional attribute worn by lepers (one figures also has bells on his legs) at carnival processions, but it was also an attribute of opponents of the Spanish occupation. According to the latter theory, these figures must be representatives of the five classes of society: kings, bishops, soldiers, burghers, and peasants.

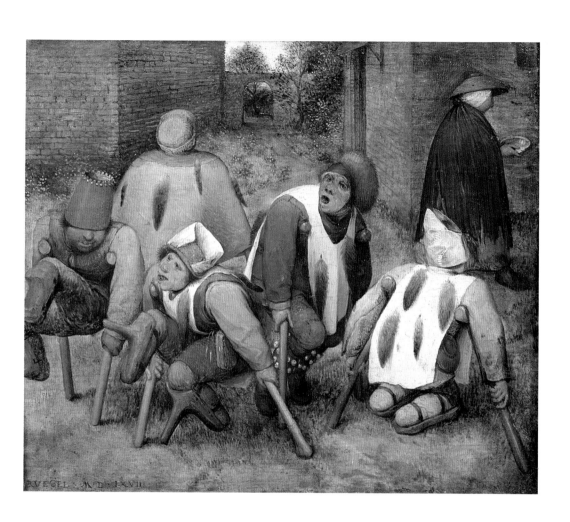

The Blind Leading the Blind

1568

Tempera on canvas, 86 x 154 cm
Museo Nazionale di Capodimonte, Naples

In 1928, the Czech art historian Max Dvořák drew attention to the innovative aspect of this painting: "... its novelty lies in the very fact that such an insignificant occurrence with such insignificant heroes becomes the focus of this view of the world." Dvořák argued that the painting simultaneously stands for the fate that no one can escape and to which all of humanity is blindly subjugated, a view that points to fatalism. The painting is based on a passage from the Bible: "And if the blind lead the blind, both shall fall into the ditch" (Matthew 15: 14, Luke 6: 39). With great compositional talent, Bruegel translates the parable into a memorable sequence of actions reminiscent of modern cinematic techniques. Everything contributes to the increased sense of precariousness that characterizes this situation: the swaying of the blind men, as they hold on to each others' staffs, the steep drop and the ditch, making it all but inevitable that the entire group will fall. The blind man who appears to turn with a shy expression towards the viewer as he stumbles forms the emotional focus of the scene. The color scheme, based on pale shades of violet, gray, and green, is quite unusual. From the point of view of painting technique, the use of tempera on canvas is also exceptional in Bruegel's oeuvre. In the background, a church is positioned in line with the "pivotal point" of the precarious balance. Isolated but firmly grounded, the church, as the source of spiritual truth, will not be able to avert the accident.

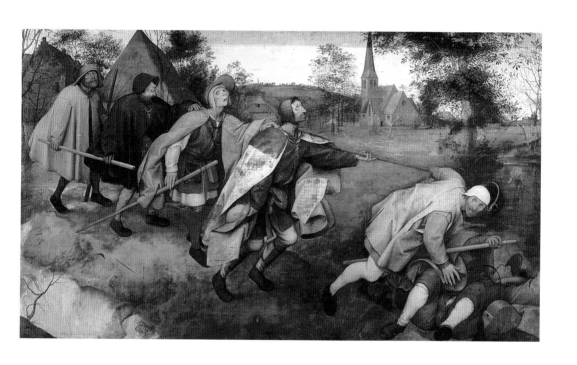

The Misanthrope

c. 1568

Tempera on canvas, 86 x 85 cm
Museo Nazionale di Capodimonte, Naples

"Because the world is perfidious, I am in mourning," reads the inscription along the bottom edge of the painting. In view of the path, which is strewn with thorns, and a person in the process of stealing the old man's purse (then emblematic of the heart), this explanation could be considered sufficient. Why, then, is the painting nowadays known as *The Misanthrope*? And what is the old man's relationship to the world? Wolfgang Stechow pointed to an inconsistency in this interpretation. If the old man's purse had already been stolen, and this unpleasant experience had led him to seek out solitude and go into mourning, the title would appear entirely suitable. Stechow argues that if, instead, he is carrying his well-concealed purse in a secluded place, the man is in fact both avaricious and hypocritical. This might also explain the choice of the tondo format, as the man is enveloped by the circle and thus occupies an ambivalent position in this "perfidious world." The tondo format has given rise to a wide variety of fascinating interpretations. The work is reminiscent of Hieronymus Bosch, both in its format and in the "monumentality" of the figures, as Bruegel distances himself from the densely populated paintings of his early period. Some interpretations read the painting as an encapsulation of the greed of clerics, while others argue that a reference to the subject of heresy cannot be excluded. Interpretation becomes all the more complicated if we include the vast landscape in the background, an idyllic view of rural Flanders with a shepherd tending his sheep. A windmill has also been incorporated into the composition. What is the meaning of the obvious contrast between the loyal shepherd and the nefarious swindler in his crystal ball, which symbolizes the world?

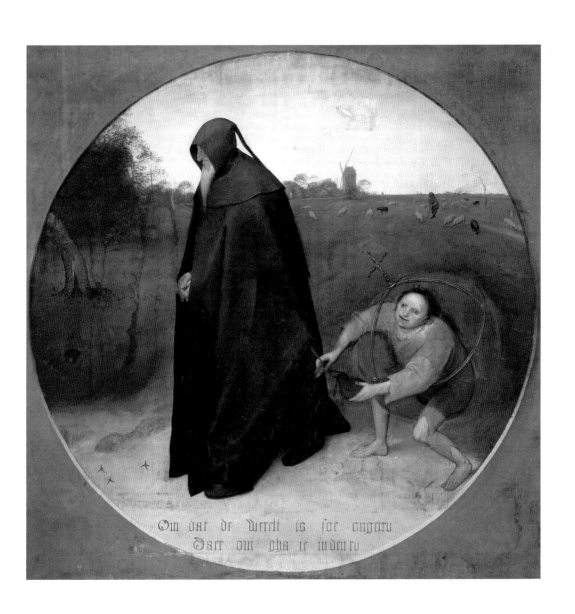

Om dat de werelt is soe ongetru
Daer om gha ic in den rou

The Peasant and the Nest Robber

1568

Oil on wood, 59.3 x 68.3 cm
Kunsthistorisches Museum, Vienna

It is now widely acknowledged that this painting, which is among Bruegel's most mysterious works, refers to a Dutch proverb: "Whoever knows where the nest is, has knowledge; whoever steals it, has the nest." The heavy-set peasant with the tight, monochrome clothes, which further accentuate his bulkiness (direct references to Michelangelo have been proposed) faces the viewer head-on and challenges us to see for ourselves what is happening in the tree. His facial expression is inscrutable, and has been interpreted as signifying everything from happy contentment to moral insight or mental vacuity. A boy is emptying a bird's nest without paying attention to the dangers associated with the activity: his cap has already fallen from his head. The "virtuous" peasant, however, faces similar calamities: he is about to fall into the brook, having already lost his purse. Or does the purse belong to the nest robber? This interpretation opens up the possibility of a reference to Jesus's words "why beholdest thou the mote that is in thy brother's eye, but considerest not the beam that is in thine own...?" The subject is not unprecedented in Bruegel's oeuvre: a famous drawing of c. 1568 (*The Bee Keepers*, Kupferstichkabinett, Berlin), shows three fully kitted-out beekeepers whose hive is being stolen by a bold boy who has climbed the tree using nothing but his bare hands. Another plausible interpretation centers on the contrast between the active (the nest robber) and the contemplative person, who allows opportunities to slip through his fingers and thus denies himself the spoils. The landscape in the right-hand section of the present painting, sun drenched, calm and bright, is particularly beautiful.

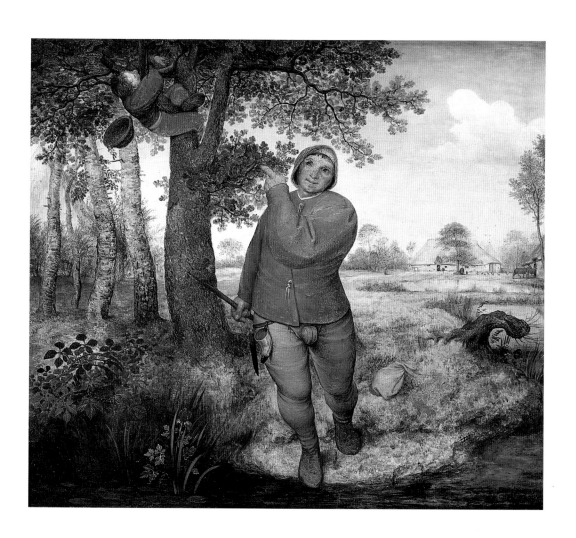

The Peasant and the
Nest Robber (details)

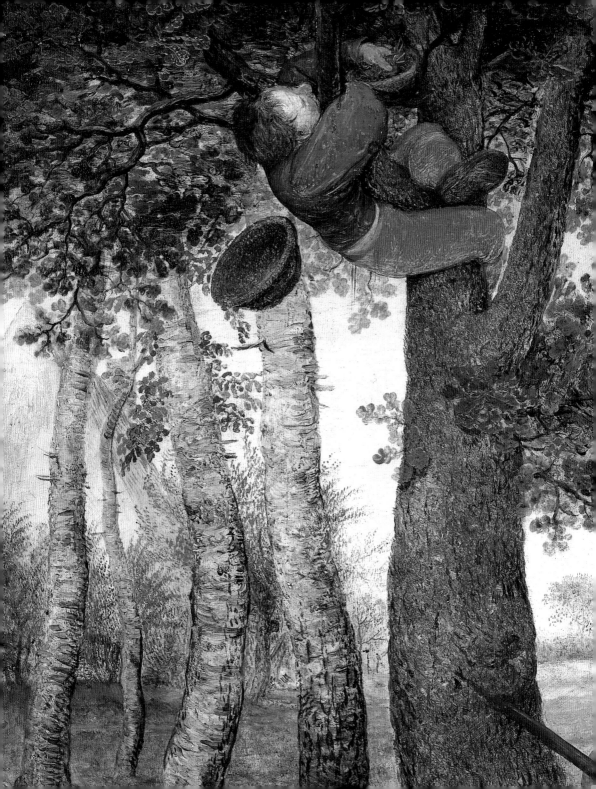

Head of an Old Woman

c. 1568

Oil on wood, 22 x 18 cm
Alte Pinakothek, Munich

This small panel reveals the tendency towards a simplification of forms in Bruegel's later "large figure" style. With a small number of exceptions, the human figure in Bruegel's oeuvre is not notable for its elegance or pleasing beauty, and the people he paints are far removed from the idealized faces to be found in Italian painting. The extreme realism with which Bruegel depicts men and women no doubt draws on direct observation of farmers, peasants, merchants, and clerics. At that time and in that region, the exertions of everyday life and the deprivation suffered were deeply engrained on people's faces. But the painter's brush mercilessly exposes more than just physical infirmity and absence of gracefulness. Men, women, and children reveal a wide variety of moral desires and weaknesses, though the views that Bruegel was a satirist or mere chronicler of the peasant world have for the most part been abandoned. One critic, Giovanni Arpino, has noted that the faces in Bruegel's work reveal "the horror that grips us when we have reached the end of our life and realize that the body is useless, vanquished, and wasted away by time. And this horror is etched into the face of the old peasant woman, whom Bruegel painted towards the end of his own life: a wretched face whose mouth is open either from surprise or fear. The skull is visible beneath the skin, as though it would soon emerge. This is not a face, it is already an object ... that will be pushed aside with a kick by a bad-tempered gravedigger."

The Peasant Wedding

c. 1568

Oil on wood, 114 x 164 cm
Kunsthistorisches Museum, Vienna

Considered the quintessential "Peasant Bruegel," this painting is a distillation of the features that make his art both great and unmistakable. The scene takes place in a simple but not uncomfortable setting, a barn with high walls made of mud and straw. The bride is recognizable by her serious and slightly dazed expression, and she is set apart by her position in front of a green cloth to which a paper crown has been attached. Her parents (or is the man the notary?) are seated on her left. It is more difficult to work out which one is the bridegroom. He has been identified in a number of different figures, from the seated young man serving the guests and reaching for plates of food balanced on the door carried by the servants, to the standing man on the left pouring ale into jugs. It is also possible, however, that the groom is not present, as there was a custom according to which the bride celebrated in her parents' house before going to that of her future husband. In the foreground a child wearing a large, bright-red cap licks its fingers with great pleasure. The guests appear to be focused on enjoying their food. On the right, a Franciscan monk sits at the end of the table, in conversation with a bearded man. Some believe that this bearded man, who sits humbly on an overturned barrel, is a self-portrait of the painter. It is worth mentioning that van Mander claimed that Bruegel liked to invite himself to festivities such as this in order to draw them from life. Looking beyond the stereotypes of the apparently peasant-like, rustic nature of the scene, the painting is nowadays considered a masterpiece of perspective, color, and the precise, closely observed representation of reality.

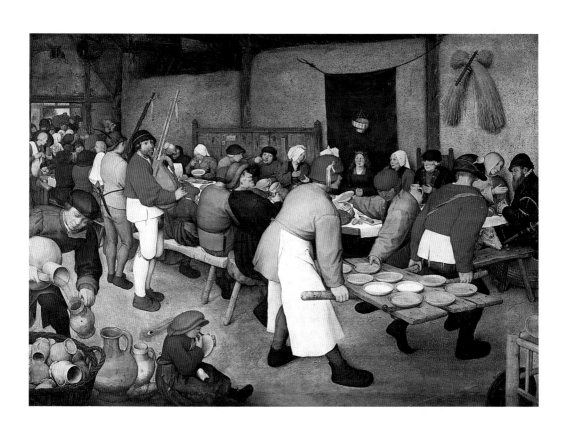

The Peasant Dance

c. 1568

Oil on wood, 114 x 164 cm
Kunsthistorisches Museum, Vienna

In its conception, theme, and dimensions, this painting is closely related to *The Peasant Wedding*. It could have been intended as a pendant, or may have been transformed into one by changing the dimensions of *The Peasant Wedding* to match this second painting. This time, the occasion for the celebration is provided not by a wedding but by a "kermesse," a parish festival celebrated with music and dancing. Such festivities were often held after the grain harvest, as indicated by the crossed spikes of wheat in the foreground and the few ears of gain in the background. In the middle ground, couples dance and a beggar approaches a table at which the villagers sit. On the right, a couple eager to dance enter the scene: a man with crude facial features, who has, rather inelegantly, attached a spoon to his hat, and a woman with a bulky physique, who, like the man, has more lusty energy than finesse. The music to accompany this traditional peasant spectacle is provided by a man playing the bagpipes, his cheeks inflated. Even the two children in the foreground play their part: like little adults, they copy the dance steps. In a remarkable reversal of previous views, current scholarship has come to reject all interpretations that read the painting as a critique of the vices of lechery, excess, and gluttony among peasants. Underneath the red banner, we see a man pulling a woman out of the house, rather than a woman seductively pulling a man into it. The painter may have considered the kermesse a welcome opportunity to record the realities of the real life and customs of his homeland.

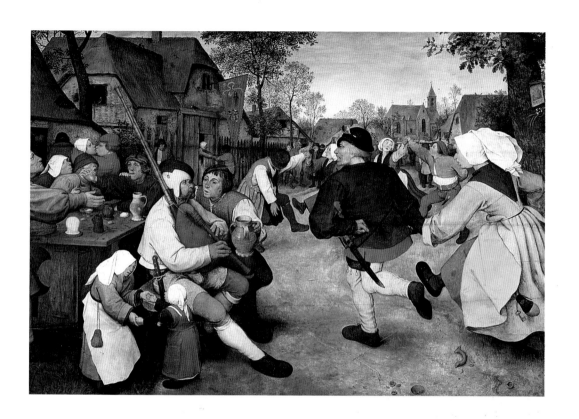

The Peasant Dance
(details)

The Magpie on the Gallows

1568

Oil on wood, 45.9 x 50.8 cm
Hessisches Landesmuseum, Darmstadt

The landscape in this painting has an extraordinary harmony and beauty. With its trees, cliffs, castles, river, and a wide plane that appears to melt into the horizon, it may be among the finest Bruegel created. It could even be said to be a precursor to those of his son, Jan, and of Peter Paul Rubens. This makes the peculiar contrast of the fine landscape with the gallows in the foreground all the more startling; the instrument of death is depicted with unsettling realism. Several peasant-like figures make their way from the village to the place where a macabre gallows, upon which a magpie sits, has been erected. It is the focal point for the entire composition. A second magpie can be seen on a tree stump a little bit farther down. Both elements, the gallows and the magpie, feature in countless Dutch proverbs and expressions, of which "to gossip like a magpie" may be the best known. The bird could thus be connected to Bruegel's criticism of gossip, particularly because he himself was subjected to it. Consequently, as he lay on his deathbed he instructed his wife to destroy certain drawings because they could have been used against her by detractors with sharp tongues. The expression "to dance under the gallows" also refers to the power of slander, which in a period of acute religious and political tensions could put nooses around the necks of the innocent. It is not clear whether it is also connected to the culture of denunciation that flourished under the Spanish occupation. The poignant effect of the scenery is heightened by the man in the foreground, who points to the magpie on the gallows. In the lower left-hand corner, a man squats in the bushes to relieve himself, in this way making perfectly clear what he thinks of the subject.

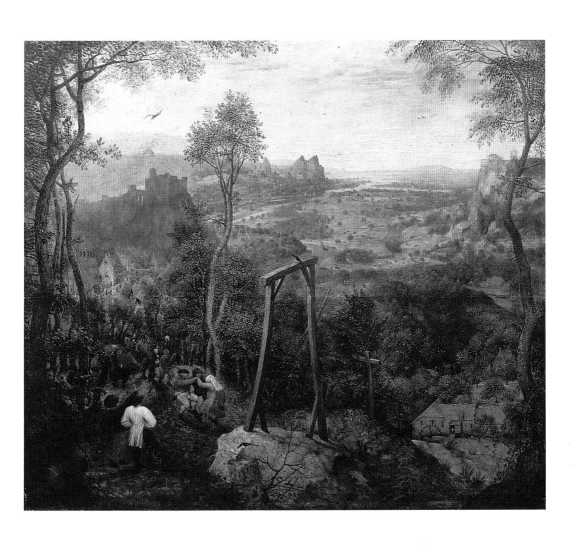

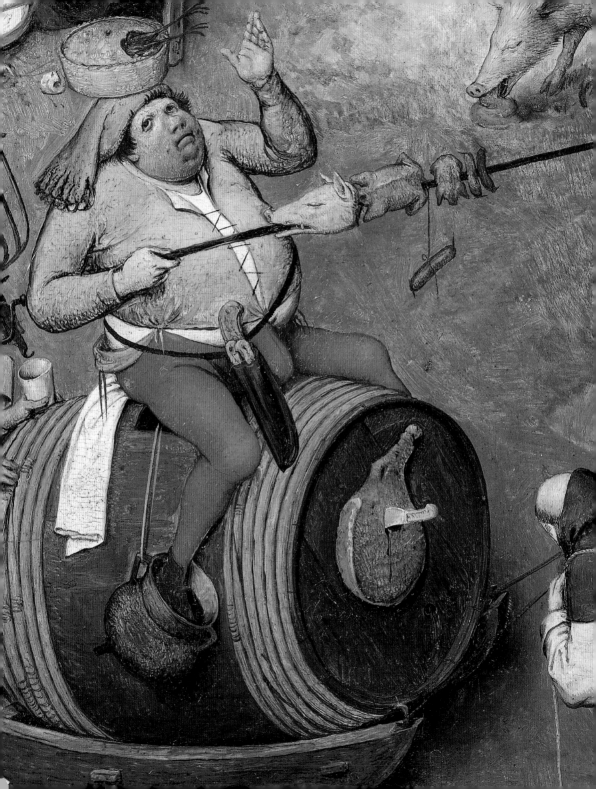

THE ARTIST AND THE MAN

Bruegel in Close-Up

In search of Bruegel's features

As the documentary information relating to Bruegel is so meager, some art historians have paid particular attention to his image. The first person to publish an alleged portrait of the artist was the Flemish poet, humanist, and artist Dominicus Lampsonius (1532–1599), who included a portrait of Bruegel, engraved by Philipp Galle, in his 1572 biographical collection *Pictorum aliquot celebrium Germaniae inferioris effigies* (Portraits of Some Famous Artists of the Netherlands); twenty-three engraved portraits accompanied by short verses (the text on Bruegel appears in the Anthology). The engraving shows in profile a bearded, very elegantly dressed man wearing an artist's hat, his expression serious, thoughtful, and composed.

Around 1565 the artist himself produced a drawing, now known as *The Painter and the Connoisseur* (Albertina, Vienna), that may possibly be a self-portrait, if somewhat caricatured. An elderly artist, his role established by the simple working smock and cap, from under which a thick mop of tousled hair emerges, is holding a paintbrush in his raised hand as he turns towards an unseen work on his easel; he seems disgruntled, impatient with the man peering over his shoulder and keen to carry on painting. The man behind is seen in profile, glasses on the end of his nose, looking rather vacuously at the painting while holding a bag of money tightly in his right hand. Is he already assessing how much the painting is worth before it is even finished? It is impossible to tell.

Art historians have repeatedly tried to identify Bruegel's self-portrait among the many subsidiary figures in his works. And it may well be the case that he wanted to record his own image in his paintings; it was not an uncommon practice, and sits well with what is generally seen as his ironic take on life. But in searching for his image we should not allow ourselves to rely too heavily on the belief that it is possible to read a person's intellectual and moral qualities from his or her demeanor and/or physiognomy.

The first self-portrait in Bruegel's work is thought to be a subsidiary figure in *The Procession to Calvary* (1564), though this claim (like many claims about Bruegel and his works) is strongly contested. Is the truncated figure on the right-hand edge of the painting really Pieter Bruegel? Here, too, a cursory glance gives the impression of a pensive figure who regards the "drama" he is witnessing with a certain detachment. He is certainly equipped with the then typical attributes of an artist, a white smock and a red cap. In *The Sermon of John the Baptist*, painted a little later, in 1566, the artist may appear again in the middle of a large crowd of people who have gathered in the open air. The small face that can be seen between the two men standing in front of the gipsy reading palms could indeed be that of Bruegel; once again we see a bearded man wearing the familiar cap, his expression inscrutable. Others have chosen to see Bruegel in the figure sitting top right on a rise; they claim that there he is shown accompanied by his wife and his mother-in-law, Mayken Verhulst.

Bruegel is said to have put in his last "appearance" in *The Peasant Wedding* of c. 1568 (Vienna). The man on the far right seems to be concentrating, thinking hard as he listens attentively to the remarks of a Franciscan monk. He has folded his hands and, unlike all the other guests, sits on an upturned barrel, not a bench or a stool; amid the guests, most of whom are busily engaged in eating, he looks like an outsider, an observer rather than a participant. According to Karen van Mander, Bruegel, accompanied by the Nueremberg merchant Hans Franckert, "a noble and upright man," often went "into the country to see peasants at their kermesses [festivals] or weddings. Disguised as peasants they brought gifts like the other guests, claiming that they were members of the bride's or the bridegroom's family."

Perhaps it was from the details gleaned from these examples—beard, serious expression, elegant appearance—that the Flemish artist Bartholomäus Spranger

(1546–1611) painted a head-and-shoulders portrait of Bruegel that was engraved by Aegidius Sadeler (c. 1570-1629) in 1606. An oval portrait medallion is flanked by representations of the gods Mercury and Minerva; above, a composite female figure represents Fama (Fame), while below a putto holds a burning torch over a skull, a reference to the artists' fame in perpetuity. The image comes at the end of a long text on the imitation of nature in art.

Friends, clients, and collectors

It would be impossible to list all the (often vague) references to works by Bruegel in seventeenth-century inventories. And the difficulty of tracking down the works in question is considerably increased by the bewildering proliferation of copies produced by his two sons and many others.

Karel van Mander names several collectors of Bruegel's works, including Hermann Pilgrims, an Amsterdam merchant who owned an oil painting of a "rural wedding," and Willem Jacobszoon, in whose collection a "country celebration" and a "peasant wedding" were to be found. Other admirers of his art were Hans Franckert, the friend with whom he liked to visit country festivals, and Peter Stevens from Antwerp, who owned Two Monkeys and ten further pictures by Bruegel. However, the most important collector of his works was without doubt Niclaes Jonghelinck, the paintings by Bruegel listed in an inventory of his possessions indicating that he had amassed a significant collection of major works. In a legal document we read: "Niclaes Jonghelinck hereby declares that on 7 September 1563 he assumed in favor of our city the pledge for Daniel de Bruyne to the amount of 16,000 Charles florins as payment of commissions for the wine excise of the city, and since until now he has offered the city no special securities, Niclaes Jonghelinck ... has hereby promised that if the above-mentioned Daniel de Bruyne should fail to meet his obligations to the city, as they are indicated in the total listed on the invoice, or as they have been deter-

mined by the director of the customs and tax administration of the above-mentioned excise duties as taxes due to the city, and fails to pay, that as guarantor he will satisfy these claims and pay the city the above-mentioned 16,000 Charles guilders. As security for this guarantee, he transfers all paintings currently in his possession, whose owner he is, and which are preserved in his house in ter Beken, namely: 10 works of the Labours of Hercules; 8 paintings of L'Art endormi, a Judgment of Paris, a Triomphe Marin, a Banquet des Justes, a painting of Spes, Fides et Caritas, all executed by Frans Floris; a painting by Albodura [Albrecht Dürer]; 16 paintings by Bruegel, including the Building of the Babylonian Tower, a painting entitled The Procession to Calvary ... paintings of the months, and many others, whichever they may be..." Jonghelinck thus had in his possession masterpieces by Bruegel that today are among his most famous works; indeed, the artist created the celebrated Seasons Cycle specifically to decorate Jonghelinck's residence.

We know very little about the life of this prosperous and influential Antwerp merchant and banker. What is certain, however, is that he was an important connoisseur and patron of art, and that he also had an artist of considerable rank in his own family in the person of his brother, Jacques Jonghelinck (1530–1606), a sculptor and medalist who from 1563 was in the service of Philip II of Spain. This artist was a member of the entourage of Cardinal Antoine Perrenot de Granvelle (1517–1586), a person who likewise played an important role in Bruegel's life.

The Cardinal was also one of Bruegel's most important patrons, and it was this relationship between the artist and the cleric that has helped to determine Bruegel's religious and political orientation—which in the literature veers, in the words of Fritz Grossmann, between the poles of "peasant and the townsman," "orthodox Catholic and a Libertine"—in favor of Catholicism. The career of the cardinal clearly shows that he himself

was an unswerving supporter not only of the Catholic Church but also of Spanish rule in the Netherlands. Though made a canon in Liège and Bishop of Arras, he was never really active in these offices because his entire life was taken up by his political functions in the service of the Habsburgs. He followed in the footsteps of his father, the imperial High Chancellor Nicolas Perrenot de Granvelle, who introduced him to the court of Philip II. After the abdication of Emperor Charles V in 1556, Philip summoned Perrenot de Granvelle to the Council of State and made him responsible for the negotiations that led to the Peace of Cateau-Cambrésis. In 1560, after he was appointed Minister to Margaret of Parma, Philip's half-sister, when she was made Governor of the Netherlands, he became Archbishop of Mechelen, and the following year a cardinal. The important functions that Antoine Perrenot de Granvelle assumed on behalf of the absolute princes of the Spanish ruling house made him an object of hatred in the eyes of the population, and especially of William of Orange, the leader of the opposition. Philip II was increasingly mistrustful of the aristocracy of the Netherlands, especially after the Dutch Revolt by the Geuzen (from *gueux*, the French for "beggars"), and feelings hardened. Such was the growing hostility to Spanish rule that in 1564 Granvelle had to retire to Besançon in France, where he devoted himself to writing. He was summoned to Rome in 1571 and crowned Viceroy of Naples, before finally being ordered back to Madrid, ending his career as Archbishop of Besançon. He was an important man of letters, patron, and art collector, and among the artists whose career he advanced were Titian, Anthonis Mor, and the sculptor Leone Leoni. The only identified work by Bruegel in his possession was *The Flight into Egypt* (1563); other works by "Pierre Breughel" were listed in an inventory of the cardinal's possessions, though they have not been identified. Among them might well have been the *Naval Battle in the Gulf of Naples* (c. 1556); a painting of the same subject was also in the possession of Peter Paul

Ruben (1577–1640). Apart from the inventory, the only other documentary source that establishes a link between the artist and Cardinal Perrenot de Ganvelle is a letter to the cardinal from Canon Morillon in which the latter observes that Bruegel's works—which even then were hard to come by—would increase in value considerably after his death.

Bruegel was also a friend of the geographer and cartographer Abraham Ortelius (1527–1598), who is known to have commissioned at least one work from him, the *grisaille* painting *The Death of the Virgin*. A eulogy Ortelius wrote after Bruegel's death permits us to conclude that their relationship was close and that he probably acquired other works by the artist, though no documents to prove this have survived. In his *Album Amicorum*, Ortelius wrote: "Pieter Bruegel was the greatest artist of his century; only a jealous rival or someone who understands nothing of painting will deny it. He was snatched away from us in the prime of life. Should I hurl my accusation in the face of Death, who perhaps believed he was already old enough to die since he had acquired such a mature and excellent talent? Or should I blame Nature, who perhaps feared he would put her in the shade because he had imitated her with such an outstanding talent, with such high art?"

So who was this Abraham Ortels, who Latinized his family name as Ortelius? A native of Antwerp, he traveled extensively in his youth, visiting many places in Europe, notably in Italy; some believe that it was he who accompanied Bruegel on his trip to Italy. In Antwerp, when he was beginning his career as a cartographer, he made the acquaintance of the celebrated publisher Christoph Plantin (Christoffel Plantijn, c. 1520–1589). In 1564 Ortelius published his first map of the world, in eight sheets; it was entitled *Typus Orbis Terrarum*, and was followed in 1570 by *Theatrum Orbis Terrarum*, the first modern-style "atlas," consisting of seventy maps by contemporary cartographers. The publication was overwhelmingly successful for a work of this kind: during the author's lifetime

it was translated into various European languages in a total of twenty-five editions, and after his death countless further editions were published, including the 1608 edition acquired by the celebrated Italian explorer and map-maker Filippo Pigafetta (1533–1604).

The keen collectors of Bruegel's works—merchants, scholars, Church dignitaries—also included an artist of outstanding stature, Peter Paul Rubens, in whose works there are echoes of his famous predecessor; no doubt his close friendship with Bruegel's younger son, Jan Brueghel the Elder, played a role in this. According to Ortelius, Rubens owned Bruegel's *Death of the Virgin*, and an inventory of Ruben's estate lists no fewer than twelve paintings by "Old Bruegel," the subjects ranging from battles and landscapes to portrait heads.

The cultural context of the sixteenth century

Without doubt, the age in which Bruegel lived was intellectually one of the most stimulating, but also one of the bloodiest as regards ideological disputes over questions of faith. Citing just a few books published during the first half of the sixteenth century is enough to give a clear impression of the cultural panorama of the age: for example *Utopia* (1516) by Thomas More, *De libero arbitrio* (1524) by Erasmus of Rotterdam, the first volume of *Gargantua and Pantagruel* (1532) by François Rabelais, and the *Institutes of the Christian Religion* (1536) by John Calvin—key works that had a lasting effect on the development of society. Bruegel will have either read them, or at least have been made aware of their ideas by others. He has been regarded as a strict Catholic, a Baptist, a "free thinker" (in other words a supporter of liberal and tolerant attitudes), and even as an agnostic. Scholars have scoured his paintings and graphic works for clues to his personal beliefs, a key work in this quest being *The Sermon of John the Baptist* (1566) in Budapest, for in it we find an explicit reference to the open-air sermons attended by the Reformers. But as some commentators have rightly pointed out, Bruegel's

close and well-documented friendship with Ortelius, who was in the service of the reactionary Catholic Philip II, and also his relationship with Cardinal Perrenot de Granvelle, an agent of the king, rule out a "Reformation" interpretation; it seems safe to assume that Bruegel was a more or less convinced Catholic. Nevertheless, we should not forget that his move to Brussels was previously seen as proof of the fact that he was accused of heresy; that he was regarded as a "free thinker" (like his friend Christophe Plantin, who had to flee to the safety of Paris in order to escape the Inquisition); and that he has even been seen as a follower of the *Familia Caritatis* (Family of Love), a heretical sect, founded by the German mystic Hendrik Niclaes (c.1501–c.1580), to which both Ortelius and Plantin belonged. In his *Speculum Justitiae* (Mirror of Justice), Niclaes, arguing that salvation lies in the universal power of love, claimed that all religions are equally a reflection of the same truth, and that Holy Scripture was to be interpreted allegorically. Here he was close to the Dutch theologian Dirck Volkertszoon Coornhert (1522–1590), who was famous for his passionate defense of tolerance and his criticism of prejudices, and also to Erasmus of Rotterdam (1466?–1536). But for some authors, notably Alexander Wied (1994), questions regarding Bruegel's precise beliefs and loyalties are largely misplaced: as an independent, well-educated man who knew a number of the leading cultural and intellectual figures of the day, Bruegel was probably not a zealous adherent of any particular party or religious grouping, and not susceptible to religious or philosophical indoctrination.

Questions of authenticity: original, copy, and imitation

One of the most serious problems confronting scholars studying the works of Bruegel is that of determining which works purporting to be by Bruegel are actually by him. This task is made all the harder by the fact that there is not a single document by Bruegel pertaining to

his works, and that the inventories of the collectors of his works (notably Jonghelinck, Perrenot de Granvelle, and Giulio Clovio, the Italian artist with whom Bruegel work while in Rome) are vague or inaccurate. Incidentally, Bruegel himself appears not to have given any of his pictures specific titles. Those traditionally used generally identify the immediate subject of the picture rather than its theme. The paintings in the Seasons Cycle are good examples; in recent literature there has been a tendency to replace well-established titles, such as *The Hay Harvest* or *The Hunters in the Snow*, with titles that refer to the broader significance of the paintings, in this case *Early Summer* and *Winter*, since the intention of the pictures is to portray these seasons.

On the other hand there are some works that Bruegel actually signed and dated (initially he signed himself "brueghel" in lower-case Gothic lettering, then from 1559 "BRVEGEL" in Roman capitals and without the "H"). Signatures are very important when attempting to establish the canon of his authentic paintings and drawings, but they need to be examined very carefully; more than once it has been proven that a signature was not genuine (as a signature greatly increases the value of a painting, it is often added by another hand, usually after the artist's death). Only a thorough stylistic analysis and—importantly—radiography, chemical analysis (of paint), and dendrochronological analysis, which is based on dating the wooden panel on which the picture is painted, can supply reliable information regarding the authenticity of a work.

A precise study of his painting technique also helps to identify fakes and imitations. In order to increase the effect of the colors in his paintings, Bruegel used a thin layer of paint as a ground. This enabled him to apply the paint lightly and smoothly, in a way that a number of Impressionists would later endeavor to imitate. In general his palette has a limited spectrum of colors, and the figures are developed primarily through the drawing rather than the interior modeling of the forms.

The most serious problem of all for researchers, however, continues to be the numerous works derived from those of Bruegel. We know that his son Pieter in particular was skilled in copying his father's works. Some of Bruegel's pictures have in fact survived only in the form of copies, the originals having been lost. But his son did not content himself with merely copying; he also created works in the style of his father, a fact that makes attribution even more difficult. In 1967, Piero Bianconi described the continuous additions and subtractions in Pieter Bruegel's catalogue of works, which today list some forty paintings, as follows: "Erroneous or generous attributions, which are sometimes not entirely disinterested, determine research today, following the crude questionings of the early twentieth century, and lead to a dubious trend towards inflating the catalogue of works once more."

There is in any case an inevitable degree of uncertainty with regard to Bruegel's early work. Although in this phase (at least until 1559) he concentrated on drawings—for transfer to copperplate engravings, or as independent works—he is known to have executed several paintings around this time. Some of them have survived and are to be counted among his most famous works, even if the paintings we have are probably only copies, an example being *Landscape with the Fall of Icarus* (c. 1558). Others are recorded only as items in inventories or as descriptions. Though it is possible that a number of early paintings have been lost, it is safe to assume that the scarcity of paintings from this period indicates that initially Bruegel was primarily a graphic artist.

In any case, in both graphic art and painting his preference for landscape is clearly discernible; here Bruegel continued the tradition of the Flemish artist Joachim Patinir (c. 1480–1524), while at the same time demonstrating a certain affinity with Hieronymus Bosch (c. 1450–1516), certainly as regards the depiction of human folly or the temptations of the saints. For the period before 1559 there have been no lack of attributions of paintings on ru-

ral themes (peasants' dances, village celebrations, portraits), though in most cases these have turned out to be unsustainable. With the three great didactic paintings of the years 1559/60 (*The Netherlandish Proverbs*, *The Fight Between Carnival and Lent*, and *Children's Games*) and the three paintings with subjects close to the themes of Hieronymus Bosch (*The Fall of the Rebel Angels*, *"Dulle Griet" (Mad Meg)*, and *The Triumph of Death*) we are treading on firmer ground. But even for a painting from 1564, *The Massacre of the Innocents*, there was a problem that was only recently resolved. For a long time scholars were divided: some considered the Vienna version to be the original, others the version at Hampton Court. The latter, in which the more drastic representations of the massacre of the children have been removed, was finally accepted as the original. It should nonetheless be pointed out that the version in Vienna, which today is attributed to his son, Pieter Bruegel the Younger, was of immeasurable value in reconstructing the elements erased from the original version.

Complicated problems of attribution arise even with regard to 1565, a central year in Bruegel's career. While there are no old copies of the paintings in the Seasons Cycle apart from a single case (because they were the property of the emperor and thus not accessible to other painters), there are more than sixty copies of the *Winter Landscape with a Bird Trap*, the version in the Musées Royaux des Beaux-Arts in Brussels being by Bruegel himself. *The Bad Shepherd* also aroused the interest of copiers and imitators, but in this case it seems that the original has not survived, and so we have to form an impression of it from the various copies; these at least allow us to see that it was doubtless both the rural theme and the originality of the perspective that stimulated the demand for copies. *The Wedding Procession* (Maison du Roi, Musée Municipal, Brussels) has caused even greater confusion. Once attributed to Pieter Bruegel the Elder, it is now widely seen as a copy by one of his sons. The situation regarding *The*

Attack, or A Peasant Couple Attacked by Robbers (University Art Collection, Stockholm) is different again. Its attribution was always problematic, so that it has at times been considered to be a copy by Pieter Bruegel the Younger after a work by his father, and at others to be a copy by Pieter Bruegel the Younger of an original composition by Marten van Cleve (1520–1570)—a view that predominates today. The problem of authorship with regard to Bruegel has also led to unexpected results concerning a painting that was once considered to be his last work: *The Storm at Sea* in the Kunsthistorisches Museum in Vienna. Although it is understandable that scholars should want to identify a noteworthy work to mark the end of the career of a great artist, in retrospect it is surprising—and indicative of the extent to which research into Bruegel and his work is so often left groping in the dark—that a seventeenth-century painting (from c. 1610–1615) could have been attributed to an artist who died in 1569. Today the work is regarded as having been painted by the Flemish artist Joos de Momper (1564–1635).

The wisdom of *The Netherlandish Proverbs*

An integral part of the culture of the Netherlands since earliest times, proverbs became especially popular following the publication in 1500 of the *Adagia* by Erasmus of Rotterdam, which contains some 800 proverbs; further collections of proverbs, sayings, and jokes followed. At first sight, *The Netherlandish Proverbs* in Berlin appears to comprise a random selection of such sayings. In fact, Bruegel skillfully divided the picture into four "sections" defined by diagonals that converge on the small central structure, an open building supported by a classical column, in which a man is making his confession to the Devil (in other words, betraying secrets to the enemy). Just below, a young wife places a blue cloak, a symbol of infidelity, over her old husband (the painting was previously known as *The Blue Cloak*). This picture,

which allows us to immerse ourselves in the everyday life of the period, is in effect a translation into pictorial form of the accumulated traditional lore of a culture.

Even without specific explanations, we can recognize certain episodes instantly: for example the man who is urinating at the moon out of the attic window (aiming for the unattainable); the two women spinning (gossiping); and the soldier who runs full tilt against the wall (attempting the impossible: "banging his head against a brick wall").

It is more difficult to interpret the actions of other figures, such as the woman who is tying a devil to a cushion (it may mean she is attempting the impossible, or perhaps that wily persistence will be rewarded); the man who, a knife between his teeth, is tying a bell to a cat ("belling the cat," i.e. attempting something dangerous, though here seen ironically); the man who is shearing a pig (refusing to listen to good advice); or the man who is carrying light into the daylight in a basket (therefore wasting his time). It is only by turning to written sources that we can understand many of the individual scenes, such as why a man on the right-hand edge of the picture is falling through a basket (he has been rebuffed or has failed in some endeavor); or that someone who opens his mouth wide like the entrance to a furnace overestimates his abilities ("a big mouth"). In the middle of the picture, the lively assortment of proverbs continues, though some of the best scenes are hidden away, such as the man who fishes behind the net (fails to take advantage of valuable opportunities, or is content with what others have left behind); a depiction of the widespread saying "Big fish eat little fish"; and a man who attempts to grasp an eel by its tail (a task doomed to failure from the outset). One man swims against the current; another throws his money into the river. Tiny figures in the far distance continue to enact proverbs: a man plays the fiddle in the pillory, reminding us that in certain situations it is better not to draw attention to ourselves, while another man falls off an ox onto a donkey, meaning that he ended up with a bad bargain. Even farther back, by the open sea, a figure collects horse dung (an allusion to the proverb "Horse droppings are not figs," a warning against being fooled); two bears are dancing (a metaphor for hunger, or a criticism of man who, unlike the wild animals, does not get on well with his fellow creatures); an old woman is running away from the animals (making a virtue out of necessity); and a blind man is leading two other blind men ("the blind leading the blind"). And on the horizon we can just make out a church and its spire: the journey is not yet over, and a goal is reached only after great effort.

Bruegel's drawings and prints

Though we know of only one dated and signed print by Bruegel, *The Hunt for the Wild Hare* of 1560, many engravings were produced from his drawings and they play a very important role in his oeuvre. And in order to assess his graphic works it is necessary to consider them alongside his paintings, for his works in both media are closely related. In 1937 the German art historian Max J. Friedländer came to the conclusion that Bruegel actually began his career as a draftsman making designs for prints, and thus came to painting indirectly. Is this credible? The theory no doubt owes a great deal to the fact that only a few paintings are known from Bruegel's early years, while there are entire series of engravings produced from his drawings. It is important to remember, however, that early paintings may have been lost, destroyed, or simply remain unidentified.

In 1555 Bruegel began the series *Large Landscapes* for the publisher Hieronymus Cock, twelve views executed as engravings. Although these views usually have a specific subject (a huntsman, Mary Magdalene doing penance, St. Jerome in the Wilderness, and so on), these are subordinate to the overall impression of a landscape seen from a bird's-eye view, a perspective Bruegel used in the majority of his landscapes. The dominant motifs remain the

mountains Bruegel had so admired while crossing the Alps. Even during his journey to Italy, he had devoted much of his time to drawing after nature. We can recall here, for example, the drawing *View of Reggio di Calabria* (Museum Boijmans van Beuningen, Rotterdam) and—because the relevant drawing is missing—the engraving *Naval Battle in the Strait of Messina*, and the drawing *View of the Ripa Grande in Rome* (Chatsworth House). These not only illustrate the development of drawing and printing at the time, they also allow us to chart the course of Bruegel's journey through Italy, about which we otherwise know very little. The drawings he made during the journey (or immediately afterwards on the basis of the impressions the journey left), reach their culmination in the mountain landscapes, which are ink drawings of incredible lightness of touch. Scholars have repeatedly tried to allocate these depictions to specific places, notably Martinswald near Innsbruck, and Waltensburg in Switzerland. In addition to the topographical or documentary aspect, there is a tendency to assign to these pictures a deeper meaning, an approach which more recent research tends to discourage.

In 1556 Bruegel produced two famous compositions that are very close to the works of Hieronymus Bosch: *The Ass at School* (Kupferstichkabinett, Berlin) and *Big Fish Eat Little Fish* (Albertina, Vienna). The art market at the time demanded pictures "in the style of Bosch," and Cock knew how to satisfy that demand, even to the extent of adding the old master's name to some prints. The meaning of the first of these composition is explained in the inscription: "Even if an ass goes to school, it will not become a horse." The second print expresses a scarcely concealed cynicism: the old saying about big fish eating little fish appears in a new light when we consider that the blade of the huge knife with which the big fish is being cut open is etched with a globe surmounted by a cross, a symbol of "the world." Mention should also be made of the drawing *The Trials of St. Anthony* (Ashmolean Museum, Oxford), in which the reference to Bosch is a direct quotation. The two print series *The Seven Deadly Sins* (1556/57) and *The Seven Virtues* (1559/60) can be linked to a well-documented Flemish tradition; they too were published by Cock, with Pieter van der Heyden preparing the engravings after drawings by Bruegel. Greed, wrath, sloth, pride, gluttony, envy, and lust are the seven deadly sins in the first of the two series (which may also include *The Last Judgment* in the Albertina in Vienna); and the virtues of faith, hope, charity, justice, wisdom, restraint, and temperance are the subjects of the second (some art historians also include *Christ in Purgatory*, also in the Albertina, Vienna). Between the first and second series there was a change of style, with Bruegel overcoming the influence of Bosch and finding his own independent artistic language.

A drawing he executed between these two series, in 1558, presents a number of intriguing riddles. Entitled *Elck* (Dutch for "everyman"), it has been the subject of a range of very different interpretations. Today it is generally seen as a satire on greed. In a society undergoing the kind of rapid change seen in Antwerp in the mid-sixteenth century, money becomes the general driving force behind the interests and actions of its citizens. But such a society frequently resorts to questionable forms of spiritual nourishment, as can be seen in the print *The Witch of Malleghem* (1559), which illustrates a broad range of superstitions, quack remedies, and deceptions. Also interesting here, in the context of economic expansion, is the print series on sailing ships (1561/62); they probably also document Bruegel's love of ships, which he could study in large numbers in the busy port of Antwerp. The series *The Four Seasons*, by contrast, remained unfinished; Bruegel completed only the drawings for *Spring* (1565) and *Summer* (1568), while the two others were drawn by Hans Bol (1534–1593); the prints were eventually published by Hieronymus Cock in 1570. In *Summer* in particular we can see Bruegel's mature style, with its

highly individual form of Mannerism, a style nurtured at the time by both Italian and Netherlandish artists. In the depiction of the muscular figures, it can by no means be ruled out that Bruegel was referring back to illustrious models such as the classical statue the *Laocoön*, or even the works of Michelangelo.

We can find important graphic works even in Bruegel's final creative phase, when he was a well-established painter. These include compositions firmly rooted in the Flemish tradition (*The Poor Kitchen* and *The Rich Kitchen*, 1563), and others based on more remote models (*St. James and Hermogenes*, 1564/65, and *The Calumny of Apelles*, 1565).

Bruegel and the esoteric

Among the plethora of interpretations that Bruegel's art has generated since his own day, one idea recurs: that directly or indirectly his works embody alchemical ideas. It is a suggestion that has been widely debated, though it should be pointed out that in view of the meager documentary sources regarding Bruegel's life and works such a claim must remain highly speculative. Even in a work assigned to his early phase, his *Landscape with the Fall of Icarus*, there are elements that can be interpreted as alchemical. The Sun, which appears low on the horizon and not high in the sky as the myth of Icarus assumes, would accordingly stand for the wise man's "gold" that has been produced from mercurial water (the sea). A special significance has been attached to the fact that the shepherd is gazing not at the Sun but at the Moon in broad daylight (though in the other version of this subject he is gazing up at Icarus, who is shown flying). Even the ship is open to such a reading if we understand it as representing a crucible; and then there is the figure of the plowman (farming was frequently compared to the art of alchemy), and finally the fall of Icarus, which can be read as a metaphor for the breakdown of an "unstable mixture." What is more, in Greek mythology Daedalus, the father of

Icarus and the man who made the wings for his son, is closely linked with the labyrinth, an important symbol in alchemistic lore.

In this early creative phase we can also find a drawing, one of Bruegel's most famous, in which the theme is explicit: *The Alchemist* (1558, Kupferstichkabinett, Berlin). It shows a room that looks very like a laboratory, filled with distilling flasks, powders and potions, vessels and bellows—in short, the paraphernalia of an alchemist who has sacrificed his last penny to his obsession, at the expense of his family—his wife is searching in vain in a bag for coins, while his children are raiding a bare cupboard looking for something to eat; the empty cooking pot on the head of one of the children is an amusing reference to the need and penury that reign in this household. On an engraving after this drawing there is a Latin inscription that can be translated as "The ignorant must gain knowledge and then act," which clearly suggests an alchemical theme in Bruegel's works. But had Bruegel really been initiated into the secret arts? And how do we interpret the mysterious figure sitting on the left-hand side of the picture, the "Scholar" who is pointing in a tome to the words "ALGHE MIST," a pun playing on the word "alchemist" and the Dutch for "everything has gone wrong"? Is Bruegel here satirizing alchemy in general, or just a foolish individual who has tried to emulate true alchemists? An inscription on another engraved version of this design reads "The alchemist wastes all his fortune and all his time," which seems rather to be a criticism of all the greedy, simple-minded fools who squander all they have in their search for untold wealth. The epilogue to this scene is highly revealing: in the background we see the couple forced by financial ruin to hand over their children to the poorhouse.

Esoteric content could also play a part in the famous painting *"Dulle Griet" (Mad Meg)*, dated 1562. The descent into the Underworld is often seen as an allusion to the process of initiation, and the presence of a number of

symbolic elements, such as spheres and broken eggs, invites an alchemical reading. The year 1562 is also the year in which Bruegel produced the ink drawing *The Resurrection of Christ* (Museum Boijmans van Beuningen, Rotterdam). The following alchemical interpretation was proposed by the Belgian historian Jaques van Lennep in 1965: "Like the stone, Christ leaves the darkness of base matter in order to enter the Kingdom of Light. This transformation takes place inside the *athanor* [an alchemical furnace], which is symbolized by the wooden Cross. Inside, the elements of the amalgam, in order to be sublimated from the bottom upwards so as to re-emerge purified, suffer a temporary death, like Christ. The bundle of twigs and the grave are the symbols of this process of purification, which matter must endure before the color red appears, the color of the philosopher's stone. In spiritual terms, this means that the presence of Christ on Earth corresponds with the humbling of the adept, who has to seek the interior of the Earth in order to find the hidden stone."

The Brueghels: a family of artists

We have very little information relating to the childhood and youth of Pieter Bruegel, and so it has not been possible to establish whether he came from a family with an artistic background. The only details we have are very vague and were recorded by Karel van Mander, who claims Bruegel came from peasant stock. It is generally assumed that Bruegel's first contact with a paintbrush took place during his apprenticeship under the eclectic artist Pieter Coecke van Aelst (1502–1550), whose workshop was frequented by famous personalities of Flemish artistic and intellectual life. Among them was his brother-in-law Jan van Amstel (c.1500–c.1542), the brother of Pieter Aertsen (1508–1575), a painter of folkloric scenes that were famed for their technical mastery; and also a person who would later become related to Bruegel, his future mother-in-law Mayken Verhulst Bessemers. Francesco Guicciardini

(1483–1540), an Italian writer who lived in Antwerp, celebrated her as one of the most important artists in Flanders. A miniaturist and watercolorist, she was also famous for her paintings on canvas; Bruegel's second son, Jan Breughel the Elder (1568–1625), was introduced to the art of painting by his grandmother. The first son to begin work as an artist was, however, Jan's older brother, Pieter Breughel the Younger (1564/65–1638), who became famous as "Hell Bruegel" because of the many apocalyptic scenes in his oeuvre. Today he is associated above all with the countless copies and versions of his father's, works that allow us to discern only a fraction of the brilliance of the originals. There is no question that his brother, the above-mentioned Jan Breughel the Elder, who was also known as "Velvet Breughel" or "Flower Breughel," was infinitely more talented. After training under his grandmother, he went on an extended study trip that took him to Naples and Rome, where he moved in the cultural circles close to Cardinal Federico Borromeo. He traveled to Milan with the cardinal, before finally returning to Antwerp. He is incontestably one of the great representatives of Flemish landscape painting and still lifes. His flower pictures offer a real catalogue of the different species, and his landscapes, too, are of remarkable quality. He is also famous for his friendship with Rubens, with whom he worked for a long time; in Rubens's major compositions, he was responsible for painting the flowers and landscapes.

Thus the true artistic heir of Pieter Bruegel was Jan rather than the elder son Pieter. It was the son of Jan Breughel the Elder, Jan Breughel the Younger (1601–1678), who continued the workshop. Among his sons, mention should be made above all of Abraham Breughel (1631–1697), a magnificent painter of still lifes who lived for many years in Rome and Naples, where he exerted a major influence on the development of the local approach to still-life painting. The complicated story of the Brueghels as a family of artists—the "h" was used by all

the family apart from Pieter Bruegel the Elder—also has links to another family of artists, the van Kessels. Their most talented representative was without doubt Jan van Kessel (1626–1679), a nephew of Jan Brueghel the Younger; his son, Jan van Kessel the Younger (c.1654–1708), worked as the official portrait painter to the King of Spain. Finally, the Brueghel family tree is further enriched by David Teniers the Younger (1610–1690), the son-in-law of Jan Brueghel the Elder. Teniers was a fine painter of genre scenes and achieved a degree of fame as the custodian of the art collections of the Archduke Leopold Wilhelm in Brussels, and as the founder of the Academy of Fine Arts there. It was his son, David Teniers III (1638–1685), incidentally, who was in charge of the maintenance of the family tomb in Notre-Dame-de-la-Chapelle in Brussels, in memory of the incomparable skill of his great-grandfather, Pieter Bruegel the Elder.

Bruegel in poetry

Along with a new critical assessment of Bruegel in the nineteenth and twentieth centuries, there was also a growing interest in the artist among writers. Poems reflected on his paintings and studies analyzed his aesthetics and beliefs. The French poet Charles Baudelaire (1821–1867) was the first to write essays attempting to reinterpret Bruegel; it is difficult to say whether he still saw the "devilishly amusing pandemonium of Bruegel the Drôle" as being entirely in the tradition of a Hieronymus Bosch; at any rate he attributed to Bruegel "a certain systematic predilection for the eccentric, a methodical process of the bizarre," finding in his works "a special kind of Satanic grace."

It was the twentieth century, however, that poets responded with particular insight and sensitivity to Bruegel's world. In 1939 the English writer W. H. Auden (1907–1973) wrote the poem "Musée des Beaux-Arts" after a visit to the Bruegel room in the Musées Royaux des Beaux-Arts in Brussels. In his study *Lo sguardo nar-*

rato. Letteratura e arti visive (2003, The Narrated Gaze: Literature and the Visual Arts), Renzo S. Crivelli claims that Auden saw in Bruegel the "universal significance of the incidental," the artist allowing the main event to appear of secondary or marginal importance, embedded in a narrative flow formed more obviously by the landscape and the course of other events. Auden focused on the painting *Landscape with the Fall of Icarus*, which, in spite of the stated classical subject, taken from Ovid, he saw as a metaphor for human indifference, of "...how everything turns away / Quite leisurely from the disaster." The American poet William Carlos Williams (1883–1963) was also attracted to Bruegel's paintings. In his collection *Pictures from Brueghel and other Poems* (1962), an entire section is dedicated to the works of Bruegel. By contrast, it was one specific painting that caught the attention of the American poet Sylvia Plath (1932–1963), her reaction being expressed in the poem "Two Views of a Cadaver Room." She saw in Bruegel's *The Triumph of Death* (c. 1562) the quintessence of his creative achievement. In this infernal panorama, marked by a mood of total despair, only two figures, found at the bottom right-hand corner of the picture, are immune in the face of the universal catastrophe. These two lovers ("He, afloat in the sea of her blue satin / Skirts, sings in the direction / Of a bare shoulder") are unaware of Death, though he is hard on their heels ("Both of them deaf to the fiddle in the hands / Of the Death's head shadowing their song"). In spite of the idyllic nature of their all-consuming love, they too will be overtaken by death.

Anecdotes and rumors

"He was a very quiet and prudent man. He was a man of few words, but he was very droll in society, and he loved to make people jump with the unexpected jests and noises that he thought up." For a long time scholars had to rely on such anecdotal remarks, in most cases—like the one just quoted—taken from Karel van Mander's

Lives, since no contemporary accounts have survived that might provide information about Bruegel's personality or his political and religious convictions. One of the most amusing stories is doubtless the anecdote about his "tally." In Antwerp, apparently, Bruegel had a flirtation with his maid. She was so untruthful, however, that he decided to keep a record of her lack of truthfulness—he took a stick and began to cut a nick into it for each lie she told. He had chosen a very long stick so that it would not be exhausted too quickly, but in the end it was still not long enough. Did Bruegel leave Antwerp to settle in Brussels in order to escape such a situation and its attendant gossip? Or perhaps also in order to forget the mendacious girl and—under the stern eye of his mother-in-law, Mayken Verhulst—to marry the daughter of his master?

Another anecdote, this time from the final phase of his life, poses a number of riddles with regard to his beliefs.

On his deathbed, Bruegel reputedly instructed his wife to burn certain drawings of his that might cause trouble for her after his death. What did these pictures show? After the death of the man who drew them, even those who had been close to him during his final years might have found it difficult to determine their precise meaning.

It is perhaps no coincidence that Bruegel's last surviving picture, *The Magpie on the Gallows*, shows a bird that according to the folk tradition of several cultures is considered to be particularly gossipy. It is still not clear whether Bruegel had to defend himself against rumors and suspicion during his lifetime. Whatever the precise circumstances of his life, it is his magnificent drawings, prints, and paintings that have survived and that continue to intrigue, delight, and enthrall.

Anthology

Quis novus hic Hieronymus Orbi / Boschius? Ingeniosa magistri / Somnia peniculoque, styloque / Tanta imitarier arte peritus, / Ut superet tamen interim et illum? / Macte animo, Petre, mactus ut arte / Namque tuo, veterisque magistri / Ridiculo, salibusque referto / In graphices genere inclyta laudum / Praemia unique, et ab omnibus ullo/ Artifice haud leviora mereris.

(Who is this new Hieronymus Bosch in our midst? Who is this painter who is so skillful that he can imitate the brilliant fantasies of the master with paintbrush and silverpoint; so skillful that he has now even surpassed him? Honor to you, Peter, as your work is honorable. Because with your compositions that delight the eye—which like those of your former master are thoroughly seasoned with the salt of your wit—you have earned ample praise, which will most certainly not be inferior to that which your noble predecessor and master once received.)

Dominicus Lampsonius
Pictorum aliquot celebrium Germaniae inferioris effigies, 1572

When someone asked the painter Eupompos which of his predecessors he had chosen as his role model, he answered by pointing to the people standing around him: "You must take nature as your model, not an artist." This statement is also appropriate for our Bruegel, and indeed goes so far that I would not call him the "painter of all painters," but rather "the nature of the painters" and thereby point out that he should be a model for all of us. As Pliny said of Apelles, he has painted many things that cannot be painted. All the works by our Bruegel are always more thought than painting. Eunapius also said the same thing of Timanthos in Jambilique. Painters who depict graceful creatures in the bloom of their youth and then want to give what they have painted an element of charm, or graft onto it the elegance that has been born of their imagination, blemish the creature they have depicted; they stop being true to their model and thus at the

same time distance themselves from true beauty. Our Bruegel is free of this weakness.

Abraham Ortelius
Album Amicorum, c. 1573

In a wonderful manner Nature found and seized the man who in his turn was destined to seize her magnificently, when in an obscure village in Brabant she chose from among the peasants, as the delineator of peasants, the witty and gifted Pieter Bruegel and made him a painter to the lasting glory of our Netherlands.

Karel van Mander
Schilder-boeck, 1604

The interpretation of Bruegel, the man and the work, from his day to ours presents a bewildering spectacle. The man has been thought to have been a peasant and a townsman, an orthodox Catholic and a Libertine, a humanist, a laughing and a pessimist philosopher; the artist appeared as a follower of Bosch and a continuer of the Flemish tradition, the last of the Primitives, a Mannerist in contact with Italian art, an illustrator, a genre painter, a landscape artist, a realist, a painter consciously transforming reality and adapting it to his formal ideal—to sum up just a few of the opinions expressed by various observers in the course of four hundred years. With the exception of the peasant, whom I think we can decently bury, each of these views, even when apparently contradicted by another, contains some part of the truth. The apparent contradictions mirror the different aspects of an inexhaustibly rich personality. The man and the work are complex and, only by keeping in mind the various aspects and by re-examining the facts behind the many assertions and interpretations, can we hope to obtain, if not a perfectly balanced and unassailable picture, at least one that does more justice to the intricacy of the situation and to the prodigious artistic wealth of Bruegel's works.

F. Grossmann
Pieter Bruegel, 1955

Pieter Bruegel is one of the truly great artists of all time. He brought extraordinary creative vitality to an already impressive artistic tradition, and left his imprint upon the landscape and genre painters who came after him. Above all and beyond his historical importance, Bruegel is fascinating as a rare individual. As an artist he created brilliant works based upon realistic observation and forceful design, but there is no doubt that his pictures were supposed to communicate and to teach, as well as to appeal to our love of beauty. Today, if we are to appreciate his efforts fully, we must reassess the social commentary recorded in his work—those underlying currents made so elusive by the chasm of four centuries and by Bruegel's conscious effort to disguise his meaning from all but a select few of his contemporaries. [...]

In the final analysis there is a remarkable consistency in Bruegel's message. What he seems to be saying is that the world is cruel and dangerous because man has made it so; but that those who wash their hands of responsibility like Pilate are not less guilty. He seems to indicate that if all men of good will were to act in unison, the world would be a better place.

As a representative intellectual of the sixteenth century, Bruegel belongs, along with Erasmus, Brant, and Agrippa, among those who were concerned with the spiritual illness of the proto-modern era, when religious fanaticism, Machiavellian awareness of political power, and unrestricted financial and mercantile predaciousness unleashed forces of chaos and suffering that stirred all sensitive men to raise their voices, pens, or paintbrushes in dismay.

Irving. L. Zupnick,
Bruegel, 1970

When we consider these works in all their variety, we cannot but take heed of [the] warning that Bruegel's personality must not be "constrained" by a too narrow definition. The current of his thought was complex. He observed the people of his time in their dramatic and peaceful moments, their existence rooted in the twin realities of life and death—death which waits silently or with terrifying presence. Bruegel meditated deeply upon these matters and expressed them courageously and with great vision, so that his work has that universal quality which we can all recognize. If he refused to portray humanity according to some ideal of formal beauty or in the light of a religious view of the universe, this is because he penetrated to the inner being of man and discovered its essential reality. His way was not to muse upon this inner reality through depths of colour turning to light, as Rembrandt did, but by precise observation and sensitive perception to convey it in the form of a direct emotion, in its most remote origins or as it comes closest to the very existence of man. And the setting of this human comedy is nature, in which he notes the restless ferment of spring, the clear light of a hard winter, the calm expanses of plains bathed in sunlight and the tragic, desolate void which, yet again, is an interpretation of space in relation to reality. This Bruegel created a precise and irrevocable image of the existence of man as he stands at the threshold of death in the inner world of his own awareness.

Arturo Bovi
Bruegel, 1971

Bruegel's literalness of mind also helps to explain the extraordinary degree to which his works—especially his paintings—have retained their aesthetic vitality and moral force. Little is known about Bruegel himself, but it is hard to imagine that he was an "intellectual" artist, constantly examining his own intentions and over-aware of what he might do, of what he could do or of what he

was expected to do. The paintings, drawings and prints never convey an impression of executive energies dissipated through mental speculation, as is the case with Leonardo da Vinci. Bruegel worked in a practical fashion, completing his pictures, as he completed many of his drawings, down to the last stroke. He was not in the habit of concentrating his efforts on the most important figures in a composition, so that in all his paintings are to be found the most exquisitely realized details, just as in Shakespeare superb lines are given to quite minor characters.

Keith Roberts
Bruegel, 1971

It is clear that [...] Bruegel cannot be understood apart from his particular artistic and social milieu. This is even truer for Bruegel than it is for his great predecessor Hieronymus Bosch, with whom he is often compared. The earlier artist depicted the universal Christian themes of sin, death and salvation. To a great extent, Bosch's literary and visual sources were the common heritage of the Middle Ages. The subjects represented by Bruegel were also of universal significance, but his interpretation of them were often more topical, more directly expressive of the bustling cosmopolitan society in which he lived and worked. [...] Bruegel's inspiration must be sought in the popular theatre and the holy day processions, in local folklore and proverb books. His works reflect the tastes and attitudes of the bankers, merchants and humanists who commissioned his paintings, or bought the prints published after his drawings. That is why any account of Bruegel's art must include a description of the brilliant Flemish culture which flourished in his lifetime.

Walter S. Gibson,
Bruegel, 1977

Two main thematic motifs can be identified in Bruegel's paintings right from the start: the human figure and landscape. In the early works these were treated separately, but in the later work they blend into a whole. Considerable influence can be attributed to the treatment of the human figure by Hieronymus Bosch, and, going back still further, to the Burgundian Books of Hours, the brothers van Eyck, and the landscapes of Patinir and his followers. At the same time Bruegel's landscapes also owe something to the Italian influences and particularly to his own drawings of nature, which provided a basis for his unique landscape paintings. The oldest approach to Bruegel's art, which is to trace its development from Bosch, calls for modification. For his contemporaries such as Guicciardini and Lampsonius, and immediate posterity, notably van Mander, he was the "second Bosch", above all because of his graphic work and particularly the demonic quality, which tended to be over-stressed. [...] Yet right from the outset the two artists can be distinguished by their starkly different intellectual attitudes: Bruegel is Bosch but in secular form. Bosch, the last of the Primitives, belongs to the very end of the Middle Ages; Bruegel, the first of the modern generation, to the beginning of the post-medieval world. Bosch's pandemonium hovers in a bottomless pit of religious fear and apprehension, full of trap-doors leading down to Hell. Bruegel's spirits and hobgoblins may rant and rave, but on the solid ground of humanist reason. In the former case they are beings whose existence is physically credible, whereas in the latter they appear merely as quotations. [...] Bosch's art has been called the ultimate "ramification of what had gone before" while Bruegel's exemplifies ascetic confinement. Both artists are "old-fashioned", but so far as Bosch is concerned, this quality is to some compatible with his own age. Bruegel's art, on the other hand, "developed

against the grain of the times", according to Jedlicka, "being an important element in an artistic scenario which was contrary to the spirit of the Renaissance".

Alexander Wied
Bruegel, 1979

As a result of his creative power, formed by his own expertise, his own impressions and his own experiences, Pieter Bruegel was to become one of the great poets in the portrayal of landscape, nature, and man. Beyond all psychological and iconological interpretation and independent of biographical and contemporary historical preconditions, Bruegel's surviving paintings form a cycle, indeed an epic of human existence in its helplessness not only in the face of nature but also when confronted with the apparently immutable course of world history.

The Tower of Babel as the symbol of the failure of human striving for wholeness, indeed perfection; the inescapable fate of the children in the horror enacted at Bethlehem; the cyclical path of the sun and the eternally recurring cycle of growth and decay of nature which it determines, are among the great painterly narratives, and not only of Flemish painting. The historicizing portrayals of the life of the Messiah which have become icons of the story of salvation, of the message of the Old and New Testament, only apparently contrast with the encyclopedic recording of games, proverbs or festival traditions, peasant weddings and peasant dances, and the fall of Icarus. They are all merely the differently weighted facets of Pieter Bruegel's all-embracing concept of nature. In his paintings Bruegel understood like no other before him and virtually no other after him to bring man and nature into harmony [...] The love of small things and events of everyday life only apparently loses itself in detail but never distorts the view of the whole, of the overall context. In Bruegel's portrayal of men, diversity has been brought into harmony with nature; the individual has been absorbed into a great whole that stands behind and above everything.

Wilfried Seipel
Pieter Bruegel, 1997

Locations

AUSTRIA
Vienna
Grafische Sammlung Albertina
The Painter and the Connoisseur,
1565
Kunsthistorisches Museum
The Fight Between Carnival and
Lent, 1559
Children's Games, 1560
The Suicide of Saul, 1562
The Tower of Babel, 1563
The Procession to Calvary, 1564
The Gloomy Day (February–March /
Early Spring), 1565
The Hunters in the Snow
(December–January / Winter), 1565
The Return of the Herd (October–
November / Autumn), 1565
The Conversion of Paul, 1567
The Peasant and the Nest Robber,
1568
The Peasant Dance, c. 1568
The Peasant Wedding, c. 1568

BELGIUM
Antwerp
Museum Mayer van den Bergh
Twelve Proverbs, 1558
"Dulle Griet" (Mad Meg), 1562
Brussels
Musées Royaux des Beaux-Arts
The Adoration of the Kings, c. 1556

Landscape with the Fall of Icarus,
c. 1558
The Fall of the Rebel Angels, 1562
Winter Landscape with a Bird Trap,
1565
The Census at Bethlehem, 1566

BRITAIN
Banbury
Upton House, National Trust
The Death of the Virgin, c. 1564
Hampton Court
Royal Collection
The Massacre of the Innocents,
c. 1564
London
Courtauld Institute of Art
The Flight into Egypt, 1563
Christ and the Woman Taken in
Adultery, 1565
National Gallery
The Adoration of the Kings, 1564

FRANCE
Paris
Musée du Louvre
The Beggars (The Cripples), 1568

GERMANY
Berlin
Gemäldegalerie
The Netherlandish Proverbs, 1559
Two Monkeys, 1562
Kupferstichkabinett
Big Fish Eat Little Fish, 1556
Darmstadt
Hessisches Landesmuseum
The Magpie on the Gallows, 1568
Munich
Alte Pinakothek
The Land of Cockaigne, 1567
Head of an Old Woman, c. 1568

HUNGARY
Budapest
Szépművészeti Múzeum
The Sermon of John the Baptist,
1566

ITALY
Naples
Museo Nazionale di Capodimonte
The Misanthrope, c. 1568
The Blind Leading the Blind, 1568
Rome
Galleria Doria Pamphilj
Naval Battle in the Gulf of Naples,
c. 1556

THE NETHERLANDS
Rotterdam
Museum Boijmans van Beuningen
The Tower of Babel, c. 1563

SPAIN
Madrid
Museo Nacional del Prado
The Triumph of Death, c. 1562

SWITZERLAND
Winterthur
Sammlung Oskar Reinhart "Am
Römerholz"
*The Adoration of the Magi in the
Snow*, 1567

UNITED STATES
Detroit
Institute of Arts
The Wedding Dance, 1566
New York
The Metropolitan Museum of Art
*The Harvesters (August–September /
Summer)*, 1565
The Frick Collection
The Three Soldiers, 1568
San Diego
Timken Museum of Art
The Parable of the Sower, 1557

PRIVATE COLLECTIONS
Naval Battle in the Strait of Messina,
c. 1552/53
*Landscape with Christ and the
Apostles at the Sea of Tiberias*, 1553
*The Hay Harvest (June–July / Early
Summer)*, 1565

Chronology

The following is a brief overview of the main events in the artist's life, plus the main historical and cultural events of the day (*in italics*).

1525–1530
Pieter Bruegel is born during the third decade of the sixteenth century. His place of birth is traditionally described as having been a village close to the town of Breda in North Brabant.
The Netherlands, under the rule of Emperor Charles V, is economically one of the strongest regions of Europe, with the most important stock exchange (in Antwerp).

1550
According to Karel van Mander, Bruegel completes his apprenticeship under the painter Pieter Coecke van Aelst (active in Antwerp and from 1544 in Brussels). In the workshop of Claude Dorizi in Antwerp, paints the *grisaille* wings of a triptych for the Guild of Glovemakers in St. Rumold in Mechelen.

1551
The name "Peeter Brueghel" appears for the first time in the list of members of the Guild of St. Luke in Antwerp (the painter's guild).
Emperor Charles V hands the Netherlands over to the Spanish branch of the house of Habsburg.

1551/52
Travels to Italy after an initial stop in Lyon, going as far south as Naples, Reggio di Calabria, and perhaps even Palermo. First known landscape drawings.

1553
In Rome becomes an assistant to the miniaturist Giulio Clovio. Produces his first known painting, *Landscape with Christ and the Apostles at the Sea of Tiberias.*

1554/55
Crosses the Alps on his return to Antwerp. Intensive work for Hierony-mus Cock, owner of the printer's workshop "In de Vier Winden" (To the Four Winds), for whom he prepares drawings as designs for engravings. In this phase he produces the series of 12 designs for *Great Landscapes.*
The Peace of Augsburg (1555) asserts the principle of "Cuius regio eius religio" (Whose territory, whose religion), which states that the ruler of a land is entitled to decide its religion.

1556
Draws *The Ass at School* and *Big Fish Eat Little Fish*.

Philip II receives from his father Charles V the crown of Spain and the Netherlands. Ferdinand I becomes emperor and gains the Habsburg native territories.

1558
Publication of the series *The Seven Deadly Sins* after Bruegel's drawings. He produces the drawings *Elck (Everyman)* and *The Alchemist*. Paints the landscape *The Parable of the Sower.*

1559
Draws for Hieronymus Cock the designs for the series *The Seven Virtues* and for some engravings on folkloric themes. Paints *The Nether-landish Proverbs* and *The Fight Between Carnival and Lent*. Changes the spelling of his name from "Brueghel" to "Bruegel."
Peace of Cateau-Cambrésis. Philip II instructs the Council of State of Brabant to execute his edicts without leniency; he finally returns to Spain. Until 1567 Margaret of Parma, the half-sister of Philip, is governor, advised by Bruegel's patron Perrenot de Granvelle.

1560

Paints *Children's Games*, and produces his only signed engraving, *The Hunt for the Wild Hare*.
Perrenot de Granvelle becomes Archbishop of Mechelen.

1562

Paints three pictures in the style of Bosch: *The Fall of the Rebel Angels*, *"Dulle Griet" (Mad Meg)*, and probably *The Triumph of Death*. Also paints *The Suicide of Saul* and *Two Monkeys*.

1563

Moves to Brussels and marries Mayken Coecke, the daughter of his master Pieter Coecke van Aelst. Paints *The Flight into Egypt* and probably the two versions of *The Tower of Babel*.
The end of the Council of Trent.

1564

Birth of his son Pieter (Pieter Brueghel the Younger, known as "Hell Brueghel"). Paints *The Procession to Calvary* and *The Adoration of the Kings* (London).
At the request of the governor of the Netherlands, Margaret of Parma, Cardinal Granvelle is recalled.

1565

Paints the Seasons Cycle for the merchant Niclaes Jonghelinck, as well as *Winter Landscape with a Bird Trap*.
Philip II increases the measures of the Inquisition; start of the persecution of the opposition, the Gueux *("Beggars").*

1566

Paints *The Census at Bethlehem*, *The Sermon of John the Baptist*, and *The Wedding Dance*.
In August the Netherlands revolts against Spanish rule. Iconoclasts destroy artworks in Catholic churches throughout the Netherlands.

1567

Among the works he paints this year are *The Adoration of the Magi in the Snow*, *The Land of Cockaigne*, and *The Conversion of Paul*.
The Duke of Alba is instructed by Philip to crush the revolt in the Netherlands. In Brussels the "Bloody Council" is appointed to suppress the rebellion.

1568

Birth of his second son, Jan, "Velvet Brueghel." Paints his last major

works: *The Beggars (The Cripples)*, *The Blind Leading the Blind*, and *The Peasant and the Nest Robber*. Probably also *The Misanthrope*, *The Peasant Wedding*, and *The Peasant Dance*. His last known work is *The Magpie on the Gallows*.
The Counts Egmont and van Hoorn, the main leaders of the rebellion in the Netherlands, are executed in Brussels.

1569

During this year Bruegel may have been commissioned to paint a depiction of the new canal between Antwerp and Brussels. Freed from the obligation of providing accommodation for Spanish soldiers. Dies on 5 September and is buried in the church of Notre-Dame-de-la-Chapelle in Brussels.

Literature

Studies:

F. Grossmann, *Pieter Bruegel: Complete Edition of the Paintings*, London 1955 (revised 1973)

Robert L. Delevoy, *Bruegel: Historical and Critical Study*, Geneva 1959

H. Arthur Klein, *Graphic Works of Peter Bruegel the Elder*, New York 1963

Timothy Foote, *The World of Bruegel*, Amsterdam 1968

Wolfgang Stechow, *Pieter Bruegel the Elder*, New York 1969

Keith Roberts, *Bruegel*, London 1971 (revised 1982)

Walter S. Gibson, *Bruegel*, London 1977

Alexander Wied, *Bruegel*, London 1979

Rose-Marie and Rainer Hagen, *Bruegel the Elder c. 1525–1569: Peasants, Fools and Demons*, Cologne 1994

Winfried Seipel, *Pieter Bruegel the Elder at the Kunsthistorisches Museum in Vienna*, Geneva 1998

Nadine M. Orenstein, *Pieter Bruegel the Elder: Prints and Drawings*, New Haven 2001

Robert L. Bonn, *Painting Life: The Art of Pieter Bruegel, the Elder*, London 2007

Louise S. Milne, *Carnivals and Dreams: Pieter Bruegel and the History of the Imagination*, London 2007

Manfred Sellink, *Bruegel: The Complete Paintings, Drawings and Prints*, Ghent 2007

Leopoldine Prosperetti, *Landscape and Philosophy in the Art of Jan Brueghel the Elder (1568–1625)*, Burlington 2009

Todd M. Richardson, *Pieter Bruegel the Elder: Art Discourse in the Sixteenth-Century Netherlands*, Aldershot 2011

Larry Silver, *Pieter Bruegel*, New York 2011

Fiction:

Claude Henri Rocquet, *Bruegel, or, The Workshop of Dreams*, Chicago 1991

Background:

Max Dvořák, *Kunstgeschichte als Geistesgeschichte*, Munich 1924. Translated as *The History of Art as the History of Ideas*, Boston 1984

Harbison, Craig, *The Art of the Northern Renaissance*, London 1995

Larry Silver, *Peasant Scenes and Landscapes: The Rise of Pictorial Genres in the Antwerp Art Market*, Philadelphia 2006

Picture Credits